JEWELS BY JAR

# JEWELS BY JAR

ESSAY BY Adrian Sassoon

## The Metropolitan Museum of Art, New York

DISTRIBUTED BY YALE UNIVERSITY PRESS, NEW HAVEN AND LONDON

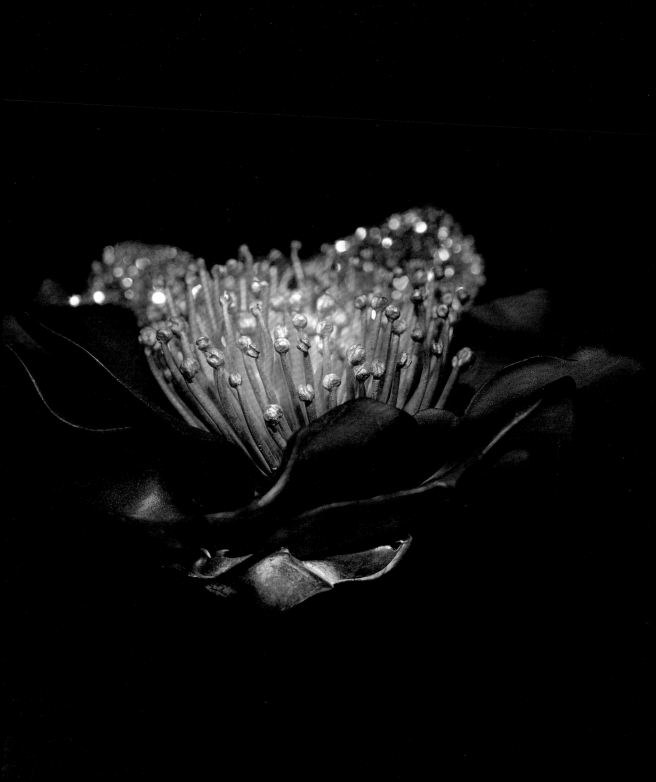

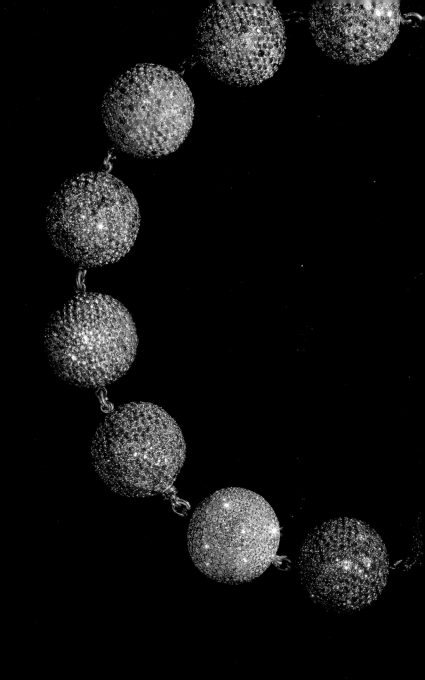

*With Infinite Gratitude*

*Just as each stone and its particular facets add to the brilliance of a jewel, so your enthusiasm, your conviction, your wearing these jewels, have made happiness at JAR, all of this mysteriously leading to our being here under the greatest roof, The Metropolitan Museum of Art. For this, we thank you beyond diamonds, beyond words.*

*— Joel Rosenthal*

# DIRECTOR'S FOREWORD

SINGULAR VISION AND A PASSION FOR EXCELLENCE are among the many superlative phrases that come to mind when considering the jewels made by Joel A. Rosenthal, known as JAR. JAR's creations recall the best of the Renaissance masters, but in their daring design and unexpected combination of gemstones they are unquestionably modern. Nature is a recurring theme in the JAR canon, with butterflies singled out for their varying and brightly hued wing patterns, along with flowers, fruit, vegetables, and other natural forms, reimagined in color-saturated bracelets and brooches.

Joel Rosenthal was born and educated in America, but has been based in Paris since the 1970s. In 1978, Rosenthal and his partner, Pierre Jeannet, opened a small boutique on the Place Vendôme. They worked quietly, alongside a small coterie of trusted artisans, and in the intervening thirty-five years they have occupied an exclusive niche worldwide. Each piece of jewelry is unique, with a conscious decision made by Rosenthal never to deviate from that deceptively simple approach.

This book, with an essay by art dealer and author Adrian Sassoon, accompanies an exhibition of more than three hundred and sixty objects at The Metropolitan Museum of Art. The Museum is grateful to Joel Rosenthal and Pierre Jeannet for making this exhibition possible, as well as to the private collectors who graciously lent their jewelry. At the Met, the keen attention of Jane Adlin, Associate Curator, Department of Modern and Contemporary Art, was also invaluable. And finally, we thank our sponsors and close friends for their generous support of the show: Phaidon Press Limited, Nancy and Howard Marks, The Ronald and Jo Carole Lauder Foundation, and Mr. and Mrs. George S. Livanos.

As a young boy, Joel Rosenthal frequently visited the Met to sketch his favorite works. It is fitting that the Museum now exhibits his works of art, making this the culmination of a personal and artistic journey.

Thomas P. Campbell
Director, The Metropolitan Museum of Art

# Observing JAR

ADRIAN SASSOON

I wish I could place a JAR jewel in your hands now,

before you read any further . . .

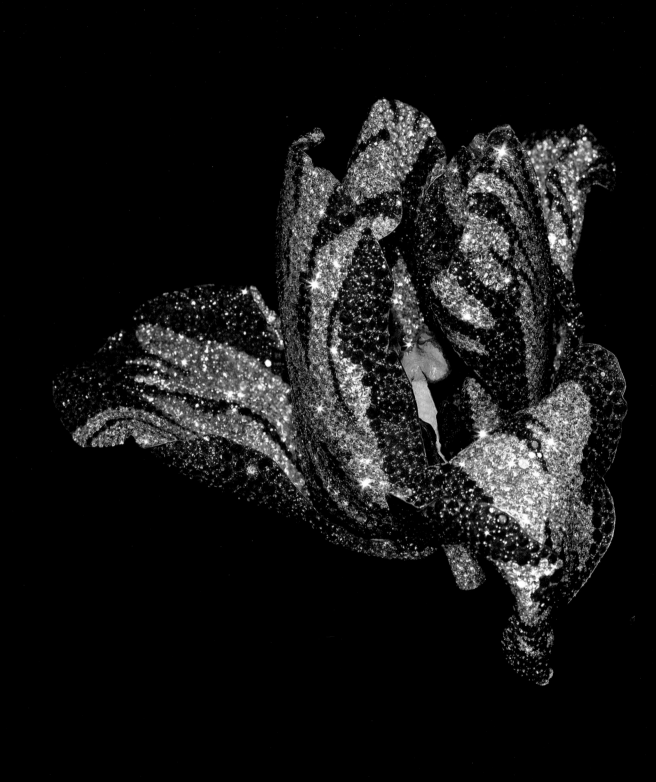

JOEL ARTHUR ROSENTHAL would prefer that we use our own eyes to look at his creations in person or through the images in his books, rather than ask him too many questions. Working under his initials—JAR—Rosenthal has an appetite to design beautiful jewels and works of art using the natural colors of gemstones, pearls, and other unlimited natural materials, set in metals that are sometimes subject to a degree of alchemy. Rosenthal's pleasure in creating these objects is more complete knowing that the owner feels wonderful when wearing his work.

For more than thirty-five years, JAR pieces have been created without concessions to publicity. Rosenthal's exceptional and novel use of color and sculptural form has led to unintended fame and a position in the history of jewelry, despite JAR objects being only minimally in the public eye. An intimate circle of people became aware of JAR jewels starting in the late 1970s, but, apart from some jewelry collectors, few in the public saw them before the mid-1990s—and even now, they are known to a relatively small audience. The significant exception to this intimacy was in 2002–3, when Joel Rosenthal and his partner, Pierre Jeannet, revealed twenty-five years of their creativity in the

exhibition "Jewels of JAR" at the Gilbert Collection, Somerset House, London. The questions of who really made these pieces and who wore them were frequently touched on at the time in newspaper and magazine articles, but the JAR manner is to let the jewels speak for themselves.

JOEL ROSENTHAL NEVER SET OUT to push the boundaries of jewelry design, but instead has followed his instincts and passions to use pure materials and explore the re-creation of natural forms in jewels. Rather than formal training in design, he relies on his senses, each of which is exceptionally sharp. His reactions to works of art are strong, and whether an object interests him or not, his recall of it will be encyclopedic.

During his childhood in the Bronx, New York, Rosenthal was fascinated by gemstones and regularly enjoyed looking at jewelry in the windows at Tiffany & Co. With his parents he also visited The Metropolitan Museum of Art, where he was first exposed to great art and where, as he now says, he "started seeing." As a child he would sketch objects in the Museum; he still has those drawings and continues to visit those same favorite works of art when in New York. The self-described boy from the Bronx became a Manhattan adolescent, attending the prestigious High School of Music and Art (now the LaGuardia High School of Music & Art and Performing Arts), where he reveled in life drawing and watercolor classes. Upon graduation he spent the summer in Rome as an apprentice at the couture house of Fabiani, above the jeweler Bulgari on the Via dei Condotti, which revived his childhood fascination with jewels. He spent another summer in Paris, pursuing his interest in fashion with apprenticeships at Christian Dior and Nina Ricci. After this taste of Europe, eager to return to Paris, Rosenthal raced through Harvard University, studying art history and philosophy and completing his degree in two years (1963–65). While at Harvard he met the film director Otto Preminger and in 1966 started working for him on the film *Hurry Sundown*. He moved to Paris later that year, continuing

to work for Preminger and other film producers and directors on scripts and translations. There he met Pierre Jeannet, who has been the other half of the JAR story since that time.

The Swiss-born Jeannet had, like Rosenthal, developed a keen appreciation for art as a child, through family holidays in Italy as well as by visiting the Kunstmuseum in Basel, where his father would often "park" him during business meetings. Starting in the late 1960s, Rosenthal and Jeannet began visiting museums, art galleries, auctions, and dealers wherever they traveled. With the usual limited funds of twenty-year-olds, they began to exercise their untrained eyes on antique jewelry, which they would purchase—often during Rosenthal's visits to Jeannet, who was qualifying as a doctor in Switzerland—and then sell to dealers in Paris or on yearly trips to Bulgari in Rome. This established a practice of buying antique diamonds and a taste for colored stones, coral, and pearls. Hans Nadelhoffer, then director of jewelry at Christie's auction house in Geneva, became a welcoming friend to the pair, and through him in the 1970s they saw exceptional collections of famous jewels, including a group belonging to the Maharani of Baroda.

In 1973, Rosenthal and Jeannet (who had also settled in Paris) opened a shop on the Rue de l'Université. This first business was a needlepoint shop, offering canvases with their own painted designs, which quickly appealed to a well-known and Parisian-based clientele, many of whom became friends. The house of Hermès commissioned the pair to design patterns for needlepoint slippers, which were produced in the Hermès ateliers. Though the business was short-lived, closing after just eleven months, during this period Rosenthal was encouraged by friends and clients to begin re-designing clients' jewels, though as Jeannet recalls they created only about half a dozen pieces.

Over the years, Rosenthal and Jeannet had often visited Bulgari in Rome, where they were shown exceptional stones. In the early 1970s, one of their good friends, who had left Bulgari and moved to Cartier in Paris, gradually encouraged Rosenthal to try his hand at designing jewelry, and in 1974 Cartier engaged him as a designer. But Rosenthal preferred the idea of working with Bulgari.

Gianni Bulgari invited Rosenthal to join his company in 1976, sending him to work in Bulgari's New York store to gain experience on the business side. While Rosenthal was in New York, he heard about the sale of the Boivin atelier, and, encouraged by Parisian friends, was convinced that there were opportunities to work there. When he returned to Paris in 1977, despite an offer from Bulgari to work

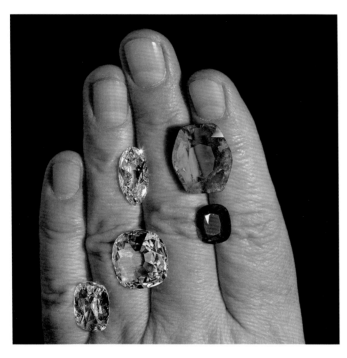

JOEL ROSENTHAL HOLDING SOME OF HIS FAVORITE STONES

for them there, Rosenthal decided to open his own jewelry business, which he simply named with his initials—JAR. From the start those initials have summed up the jewels and the business rather than the person. At that time, a great jeweler said to Rosenthal, "You'll be good at this, because you don't know any of the rules."

In the latter part of 1977, Rosenthal and Jeannet found a shop just off the Place Vendôme and began preparing a collection for the opening early the following year. In those days, the entire firm consisted of Rosenthal and Jeannet, who spent their mornings visiting ateliers, calling on craftsmen, stone dealers, and other suppliers before they opened at 11:00 a.m. As Jeannet has observed, boldly opening a shop beside the Place Vendôme, where the top jewelry houses are centered, meant that suppliers gradually started to visit them, and it also exposed JAR to the best clientele for jewelry. For a team of two novices, these were huge advantages.

At first, the majority of JAR collectors were Parisians, who in turn began to bring their friends from elsewhere. As a new business, JAR did not have the resources for a large stock of important stones, so some of the work involved remounting stones for clients from inherited family jewels and pieces that had become unfashionable. As more American visitors started coming to JAR, they wanted to see finished pieces, available for sale in the shop there and then, rather than commission pieces for the future. During the 1980s great strides were made in creating more finished stock. Three particularly creative years led up to 1987, when Rosenthal and Jeannet accumulated one hundred jewels, set aside for a special exhibition in New York. The show, "Jewels of JAR," held at the National Academy of Design on November 30, 1987, was an immense undertaking in terms of investment and atelier work for the small firm. The invitation-only exhibition lasted for three hours. Four hundred flashlights were handed to visitors to explore the jewels set out in showcases in the center of a dimly lit room. The flashlights were a triumph, but they were born of necessity, as the showcases, delivered only on the morning of the show, had been made with lighting that was unacceptable for the works of art. The visitors and resulting press coverage took awareness of JAR in the United States to a higher level and created a strong New York–based group of collectors, which has gradually expanded across the nation.

That same year, 1987, Rosenthal and Jeannet relocated the JAR shop in Paris. Though they only moved next door, they doubled their space, which allowed them to form a small staff to manage production and run the shop. Rosenthal and Jeannet were introducing more exceptional stones into their designs, made by craftsmen who have become crucial to their production.

SCULPTURE AND COLOR—the observations of nature and the plays with spirals, spheres, science, and stones—are the great features of JAR jewels. Often there is a special gem in Joel Rosenthal's hands,

one he might have owned for many years or merely hours. Sometimes favorite stones are held in very simple ring mounts so that he can have them intimately to hand, contemplating their eventual purpose. Special stones are used as the center of a ring, but they may also appear in a sculptural object such as a flower or butterfly, where they might become an understated off-center element.

At JAR, jewels are made to fulfill an ambition that is aesthetic rather than commercial. Rosenthal has often asked ateliers to make objects that others might say cannot be achieved. His deep respect for the craftsmen with whom he has worked over the years and his complete reliance on their ateliers are a crucial part of the JAR story. Ateliers take pride in being part of the process, sharing the designer's determination to make something so small, or so concealed, or so lavish, and to do it in ways so unlike anything they may have attempted before. If a JAR piece needs to be remade, refined, set aside for a while, and then started again from another perspective, so be it. The level of mutual respect between designer and craftsmen is perhaps more intense than is generally understood, and the devotion of time to each object would be commercially unacceptable in most jewelry houses.

Discussion with the head of an atelier, not pen on paper, is generally the starting point of a new design. In regular meetings with Rosenthal, the ateliers consider such challenging details as overall weight, plasticity, and novel internal mechanisms before a design idea can be convincingly implemented. Drawings on a scrap of paper might become a part of the discussion to clarify a detail, but they are never the design itself. Nor are these drawings ever scaled up into technical designs for a workshop to follow or for anyone to preserve. The process is more verbal and more tactile. A wire and paper mockup is suspended from an assistant's earlobe to judge its scale and appearance. Some patterns are inspired by cuttings of fabrics such as lace. Pearls and gems may be set in a clay model as experiments for the mounting onto a shape, and that shape itself, most often made in silver, might be reworked many times before its sculptural form is deemed finished. A nearly complete brooch is pinned to the velvet wall to be judged from a distance, or I may be asked to try the rough

structure for a cuff link on my shirt. Rosenthal draws in felt-tip pen on the silver structure of an object to describe his plan for mounting stones as their availability is discussed.

Complex JAR objects are often formed in several parts, brought together to confirm sculptural details, and then dismantled to be mounted with stones. The apparently inaccessible surfaces inside and behind the superficial facades boost the feeling of sculptural form and give the sense of deep luxury characteristic of JAR works.

The adventurous and almost unique use of unexpected metals and stones at JAR is summed up in Rosenthal's comment, "We are not afraid of any materials." Except for rings, which are usually made of silver lined in gold or platinum, the majority of JAR objects are made on a core of oxidized silver. Rosenthal aims to suppress the shine of most metals and to promote the color of the stones or pearls. The mounted silver cores are set on a similar gold backing, since silver is neither ideal against skin nor has the same strength as gold for holding the shape and forming clasps. Platinum is used for jewels requiring a white metal with strength, but it is often treated and oxidized to make it disappear beside the color of stones. Various tones of gold, in yellow, red, and green (but not white), may also be used for jewelry, as might steel, bronze, pewter, or copper. Heat-patinated titanium was used briefly in the late 1980s, and again in recent years. As a lightweight metal, aluminum has turned out to be very practical, as it is much lighter than silver and can be anodized to fairly specific colors after being set with most types of stones. One example, made in 2013, is a gem-set butterfly with its body anodized to a bright turquoise blue. Among the most exceptional pieces made with this metal are the pair of large "Lilac Brooches" of 2001 (pl. 58). These were created from hundreds of molded aluminum floral shapes cast from a variety of models, then chased to define sculptural details and mounted with a staggering total of twenty-one thousand stones.

Selecting stones for their color compatibility, complementary range, or contrast is a great skill of the JAR team. Rosenthal points out that stones for JAR pavé settings are often of inconsistent colors

but are cut to the same shape and mounted to cover as much of the metal of the core as possible. His "tweed settings," as they are known at JAR, are areas of pavé settings that wash tones across surfaces. Such color fields are created either by playing with the hues within the natural range of a given stone or by introducing different stones, occasionally brightened with tiny white diamonds. A classic piece displaying this variety is the "Colored Balls Necklace" of 1999 (pl. 46). From a distance, each sphere appears to have a single color, but in fact they are formed of blended "tweed" tones, giving the effect of a very painterly surface. Once selected, the stones and the core form are sent to the best ateliers that specialize in setting stones. A particularly challenging example of the use of color was a pair of spherical earrings from 2001 that are now publicly known to have been created for Elizabeth Taylor. What a challenge—balancing various hues of sapphires across a spherical shape to reach toward the most celebrated eyes of the twentieth century! (Taylor told Rosenthal, "Bull! My eyes are not violet; they're blue like yours!")

The unexpected always plays a large role in JAR jewels. One means of giving unexpected texture to settings is the use of reverse-mounted diamonds—referred to at JAR as "upside-down diamonds"—a JAR trick often echoed nowadays by other jewelry designers. These are mounted with the flat table, which usually faces upward, turned down into the object, while the point of the cut stone stands out from the body. Rings often contain an unexpected level of detail. Some have small-scale mounts formed of intricately twisted platinum lines set with tiny white diamonds; others are set with stones within the shank or with a circle of smaller white diamonds mounted beneath the main stone. The white diamonds are specially prepared for JAR in a traditional cut, rarely used today, that gives them a greater shine than the more common Brilliant cut. Brooches often have hidden qualities on the reverse, which, as with the rings, can only be discovered from being handled. Settings of very small diamonds, for instance, might cover parts of hinges and bridges that bring together a complex sculpture. Sometimes a small diamond is set into the clip on the back of an earring, a private pleasure

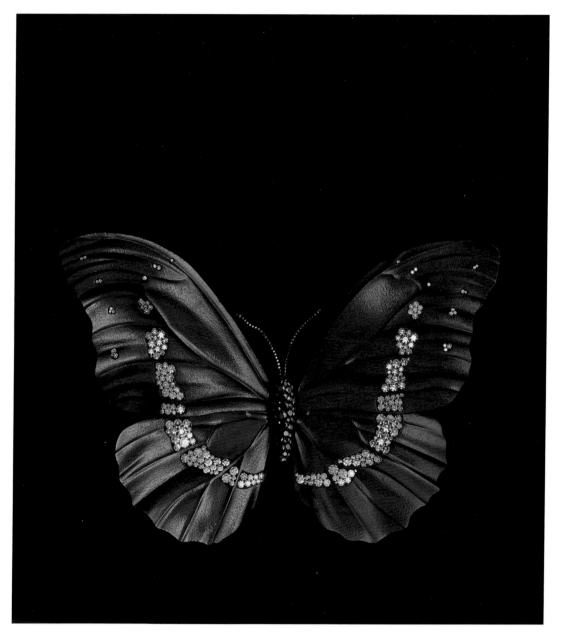

BUTTERFLY BROOCH, 2013. DIAMONDS, SPINELS, ALUMINUM, GOLD, AND SILVER

experienced only by the wearer of that piece. These intimate, luxurious details are characteristic of JAR jewels; when handling an object that one will not own, it feels like one is visiting a house when the owner is absent.

To satisfy the need for color, regular forays are made into specialist markets for cut stones, new or old, which in due course might become either the focus or the background of a jewel. Rosenthal is often attracted to varied and boldly colored gemstones that happen to have been overlooked by other twentieth-century jewelers because they are from that class of natural stone patronizingly called "semiprecious." Natural zircons are one example. At JAR, zircons are respected for their fierce blue-green color and the strong light they transmit; yet they suffer in popularity because, when colorless, their name has been diverted to refer to imitation diamonds. An open-minded appreciation of the colors natural stones offer also enabled black diamonds, which have traditionally been poorly regarded, to emerge in earlier JAR pieces. Used by JAR for many years, they have now become a mainstream component of much contemporary fine jewelry. Meanwhile, JAR has begun using black spinels rather than black diamonds, as too many of the latter are irradiated to deepen their color and, says Rosenthal, "we don't want to fry our friends."

The JAR oeuvre reveals an extraordinary range of color, using a wide variety of diamonds; sapphires in pale to deep blues, as well as in tones of violet, pink, and yellow; emeralds, including engraved Mughal emeralds; rubies of particularly deep tones; star sapphires, citrines, aquamarines, chrysoberyls, spinels, amethysts (Siberian amethysts are a personal favorite of Rosenthal's, so much so that he rarely shares them in his creations), variously colored tourmalines, topazes, peridots, garnets in red, orange, and green, moonstones in many colors, opals, and zircons. Hardstones used at JAR include agates, chrysoprase and other chalcedonies, rock crystal, jades, lapis lazuli in unusual tones, and many colors of jasper. Many other objects include materials such as coral, shell, grosgrain ribbon, carved wood, amber, or even beetle wings. In addition, antique objects and works of art that Rosenthal

and Jeannet have collected—late eighteenth- and early nineteenth-century British eye miniatures painted on ivory, eighteenth- and nineteenth-century Italian micromosaics, Antique carved cameos, Antique and Renaissance intaglios, Egyptian faience, Greek bronzes, or Chinese turquoises and other carved stones—might be incorporated into their jewels.

Collecting older gemstones and pearls is an endless pleasure for Rosenthal and Jeannet. When using them in jewels, Rosenthal preserves the antique cuts and treasures their sometimes irregular shapes. He might reduce the glaring brightness of a new stone by recutting to defuse its modernity, but an antique stone will be touched only to trim a defect and to be repolished. Certain stones rarely appear in JAR jewels; few pieces include yellow diamonds, for example, since Rosenthal simply is not keen on that color, although he does use yellow as an essential element in the observation of nature. As Rosenthal has said, he won't use "bluff stones"; for him a good spinel is far preferable to a miserable ruby.

Rosenthal and Jeannet have continuously collected diamonds from mines in the region around Golconda in India that were exhausted by the mid-nineteenth century. Having used old diamonds for many years, they have interested collectors in having new JAR pieces made from these stones. This culminated in 1999 in an extraordinary JAR necklace of five strands of Golconda diamonds that was commissioned by a husband who wanted something unprecedented for his wife's birthday. The rows of diamonds hang unevenly and are composed of stones of varying and unmatched shapes and sizes, but they are still strung and hung like a multistrand pearl necklace.

For many years Joel Rosenthal wanted to write in diamonds. His *baques écriture*, or "written rings," reproduce his own handwriting and often form deeply personal messages, expressed through a word or name spelled out as a trail of diamonds around the finger. Pierre Jeannet mentions that many people who have received a handwritten note from Rosenthal remain as captivated by his handwriting as by the message. The skilled stone setters that work with Rosenthal painstakingly set

tiny white diamonds into fine twisting lines of metal, usually platinum, to re-create that handwriting. Under microscopic examination the levels of finish are astonishing and a testament to the man-hours and skills required, the cost of executing this fine work bearing no relation to the value of the metal and stones. Wood is also a background for JAR writing in diamonds, as is rock crystal, a material much less easily worked.

The antique pearls that Rosenthal and Jeannet acquire chiefly by collecting necklaces and other jewels are natural salt- and fresh-water pearls displaying a wide range of colors; cultured or tinted pearls are never used. The jewels made with natural pearls (including conch pearls) are outstanding. Pearls are often sensitively matched to stones of various colors in some objects and to diamonds in others. At JAR, precious metal and gemstones serve to present and honor the rare pearls, as if to place them in a treasury.

Joel Rosenthal has made relatively few formal necklaces of larger stones, but he has created sautoir-style necklaces, generally made in lengths that wrap around the neck several times. These necklaces display Rosenthal's enjoyment of collecting gems cut as beads, as well as pearls and coral. (The corals range in date from the eighteenth century to the present.) Various models of oxidized silver rondelles and beads are used in these

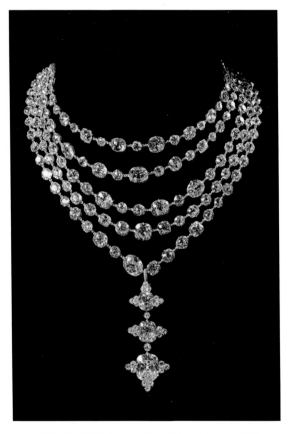

MULTISTRAND NECKLACE, 1999. DIAMONDS AND PLATINUM

sautoirs. They are pavé-set with white diamonds or other strongly colored stones and then strung at irregular intervals among the beads to create a painterly rhythm along the necklace. Opaque gray diamonds specially cut into faceted shapes have been used for one such sautoir, which to the casual viewer might look like a decorative daytime piece but which, in customary JAR fashion, features a blend of both highly and rarely regarded natural stones.

Two significant groups created by JAR over the years are the magnificent flower and butterfly brooches, each one a unique piece. Their combination of sculptural form and intense color exemplifies the impact of JAR on the history of jewelry. The butterflies, as well as moths, sometimes include major gemstones, although, typically for JAR, they are less often set as the central feature of the body and are instead introduced wherever the natural pattern demands. They are very three-dimensional, varying considerably in size, and they convincingly express movement, such as the beginning of a flight, gliding, or delicate moments of rest and pause. When many of these butterflies and moths were shown at Somerset House in London in 2002–3, they were arranged rising across a wall toward the end of the exhibition. This "butterfly wall" became perhaps the visitors' most talked-about memory of the works of art, which are unparalleled in the presentation of these insects' variety, drama, and boldness.

Flowers in bud, in full bloom, or with falling petals are another important chapter in the JAR story. Rosenthal has scant interest in regularly shaped flowers; he aims to capture more the role of chance in nature. The first JAR piece to enter a major museum collection—the Musée des Arts Décoratifs in Paris—was appropriately a camellia bracelet made of silver, rubies, and enamel. A variety of flowers, such as violets, camellias, pansies, poppies, tulips, roses, hellebores, and the blossoms of various fruit trees, have been the inspiration for JAR jewels. Just as you can peel away the petals of a fresh flower and find the next petal's color and shape inside, so you feel you can do the same with the jeweled petals of a JAR flower. The sections of these jeweled flowers are made separately, set with gemstones, and then mounted together to form the whole flower. This way of making the jewel

allows stones to be mounted deep inside a flower sculpture, an indulgence that projects a level of awareness that the gems are there without being fully visible. This is key to the lavishness of these depictions of nature.

A balanced range of rings, brooches, bracelets, necklaces, earrings, and other jewels intended to be worn are produced gradually and constantly by the workshops for JAR. He makes objects beyond women's jewelry, for example a very small number of men's cuff links and table-placed treasures such as picture frames, clocks, and small sculptures and boxes. In 2002, JAR made a formal *épée d'Académicien* (sword and hilt) for a member of the French Académie des Beaux-Arts.

Many JAR jewels other than rings deliberately underplay the rarity of the main stone, a feature often remarked upon by journalists that reflects Rosenthal's "why not?" approach to design: Why not have a valuable blue or exceptional white diamond set to the side of an object, where that color is needed as part of the sculpture? This open approach extends beyond the placement of the stones in a jewel, to the way that jewel is worn. Why not have a family of small flowers or petals flowing from shoulder to chest? One massive tulip brooch was designed to sit atop the shoulder, demonstrating Rosenthal's desire to see a large jewel perched in a spectacular way. The owner of the piece told me it was indeed wonderful to wear—until she tried to put on her coat to go outside.

Photographs of JAR pieces sold at public auctions were among the first images of Rosenthal's jewels to be published and become widely available for other designers to scrutinize. Groups of pieces were sold in the mid-1990s by one collector, and in 1998 the collection of an iconic French actress and beauty was sold after her death. From that period on, the inspiration of JAR began to be seen in jewels designed and made elsewhere. Settings in blackened silver, lines of tiny diamonds, new choices and cuts of stones as well as bold color combinations, attention to the reverse, and other characteristics of JAR jewels have become what is too kindly called "an influence" on other designers. Copyists are the plague of all creators, and while Rosenthal has not invented flowers, of course, his use of materials,

his use of color, his eye's and mind's quirks are now everywhere. Rosenthal has said that when he finds costume jewelry based on his work but made of distinctly nonprecious materials, it does amuse him.

Months before the "Jewels of JAR" exhibition at Somerset House in London, Rosenthal launched JAR Parfums, which had been in gestation for a number of years. He had been seriously interested in creating scents and, as with jewelry, was told at the outset by a professional perfumer, or "nose," that he would be good at this because he had scant regard for the rules of the profession. His intention was to sell both his scents and nonprecious jewelry in a separate boutique, completely apart from his fine jewels. JAR Parfums opened in Paris in 2002, a block away from the main shop, and a small branch opened subsequently in a department store in New York. Typical of Rosenthal, the perfume is sold in an intriguing circular bottle without a flat base, so that it can never stand upright in a conventional manner.

Rosenthal designed and produced two models of violets and pansies as aluminum ear clips, each anodized in several colors, for the museum shop to sell during the 2002 Somerset House exhibition. These were far less expensive than any jeweled JAR pieces but were made, and continue to be made, in the same atelier as some of the most elaborate jewels. Another pansy, ear clips of a special and more complex shape, was designed and made in anodized aluminum, engraved *Merci*, and sent to each of the lenders to the exhibition. This model of earring has never been for sale. Since then Rosenthal has enjoyed designing more aluminum and cast resin flower-, petal-, and fan-shaped ear clips, all made in relatively small quantities. They are never shown or sold beside the JAR jeweled pieces but have many times been offered for resale on the art market as if they were rarities, which they are not.

NOTHING IS TAKEN FOR GRANTED at JAR, and the attention to detail extends even to the famous pink boxes that contain the jewels. Since 1978, JAR jewelry boxes have always been covered with

pink leather. What I had not anticipated until I witnessed it at the shop one day is that even the colors of the silk lining of the lid and the suede covering the lower section of the interior of each box are chosen to suit the unique finished piece that it will contain. Rosenthal selects the lining colors for each box from swatches of silk and suede that he has previously distilled into a range of preferred choices. When JAR began, Rosenthal and Jeannet worked with an older craftsman who made their boxes and supplied them with beautiful leather dating back to the early nineteenth century, as well as silk velvet woven in 1915 that they used in their displays. The boxes' lids are often embossed with the initials of the owner, the date of an occasion such as a birthday, or, when objects are sold to owners with titles and nations to their name, appropriate heraldic symbols, coronets, or crowns. Rosenthal sometimes encourages collectors to abbreviate deeply private familiar names and personal messages to the first letters of those words, which are then embossed on their box's lid. Intimacy surrounds the jewel from the moment it is placed into the hands of its new owner. The making of special objects for special moments is a large part of the sincerity of the JAR story.

Joel Rosenthal carefully considers every step in the creation and also the presentation of a JAR jewel. He often encourages women to wear one jewel only—a pair of earrings or a brooch, but not both and a bracelet. It is rare for him to be absent at the moment when a collector sees, discusses, handles, and perhaps purchases an object. Most JAR jewelry is made without a particular collector in mind, just following Rosenthal's instincts and interests in shapes or stones. Some extraordinary jewels develop because a client and the designer have become close and the piece is a natural outcome of their friendship. This might be a much admired client who over many years has sat with Rosenthal while he designs pieces specifically to suit her. Rosenthal rarely discusses intricate design details, even for a semicommissioned jewel. A rare few pieces are made with a certain collector in mind, who will be shown the piece first but who is most certainly not obliged to purchase it. Important events in the life of a family are often commemorated with names or wishes on the surface of a wood

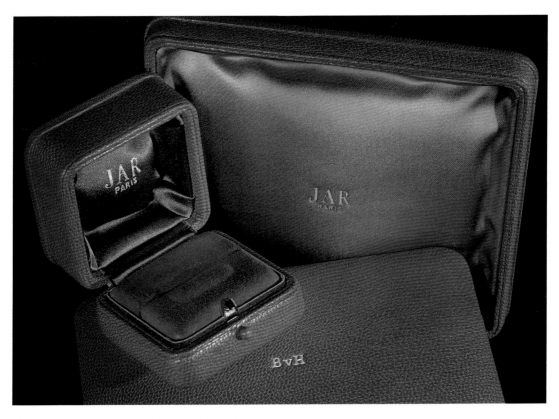

JAR JEWELRY BOXES. LEATHER, SILK, AND SUEDE

or hardstone box or on a *bague écriture*. For men, dates of birthdays or anniversaries are sometimes recorded on cuff links in symbols and Roman numerals with diamonds or other stones having subtle significance. Nowadays, a request to reset a stone from someone's old ring or other jewel is met with hesitation, since the object may be less personal to Rosenthal if the stone, let alone the client, is not one he likes. There are some interesting exceptions: for example, when family pieces are reset for the present generation, or when a male friend has inherited his mother's earrings and realizes that cuff links would be more useful.

JAR has never sought press, nor has the house been closely associated with the fashion world, although American *Vogue* once asked Irving Penn to photograph JAR jewels for a double-page spread. Despite many requests, the widespread practice of lending jewelry to magazine and fashion shoots, couture shows, or even to friends has been virtually nonexistent at JAR. This avoidance of publicity, both personal and professional, has created a myth in the press that JAR pieces are only shown to a small group of people. In fact they are mainly shown *by* a small group of people, Rosenthal and Jeannet themselves, and that brings its own natural limitations. The JAR shop is almost as personal a space as a home, and visitors are welcomed on that basis. Moreover, no matter who they are, visitors are treated equally and are indeed judged on how they react to the jewels. If someone wants a large parure of yellow diamonds, this is not the place to look; likewise, if a visitor desires a ring identical to one already made for someone else, he or she will be turned down. Personal objects are never reproduced at JAR.

TO A CASUAL PASSERBY the JAR shop off the Place Vendôme looks like a clean but perhaps dormant office space. A folded pink velvet screen is all one sees in the windows. The name of the company is barely visible, engraved in a mirror over the door that does not appear likely to open, and even the doorbell is not very obvious. A solitary small display niche in the window, lined in the same pink velvet and set in the screen, is most often empty. In keeping with the liberty and humor of the JAR style, sometimes a collected special nonprecious stone or glass object or a fresh flower is set in the niche, but never a JAR jewel. Once, years ago, during a spring cleaning of the shop, a roll of paper towels was in the window with a watch strapped around it and a note saying, "We won't be long."

In the decade since the 2002–3 exhibition, more JAR works have been thrust into the public eye through the sale of various pieces at auction and their reproduction across the Internet in articles,

auction house websites, and enthusiasts' online commentaries. As these pieces have become visible, so have the names of some of the owners whose lives have moved on or sadly ended since they acquired them. Jewelry collecting is a balance between discretion and reputation. That a pearl belonged to a maharajah or a suite of emeralds to a certain princess adds romance and interest to that object. Many collectors, however, want to have jewelry that they associate with their own lives, not with people they never knew. Consequently, a jeweler such as Joel Rosenthal can have a huge impact on a generation, making works of art for people of his own era. The nature of the process of design and the creation of unique objects inspired by one designer dictates that one day there will be no more new JAR pieces. This is the work of one eye for one generation.

THE JEWELS

I. CAMELLIA BROOCH, 2010. Rubies, pink sapphires, diamonds, silver, and gold

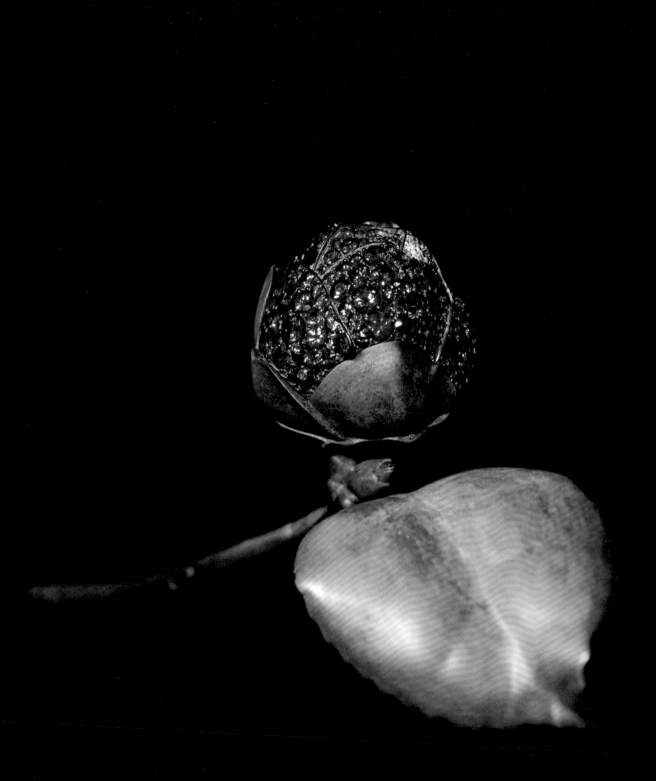

2. RIBBON PENDANT EARRINGS, 2005. Diamonds, silver, and gold

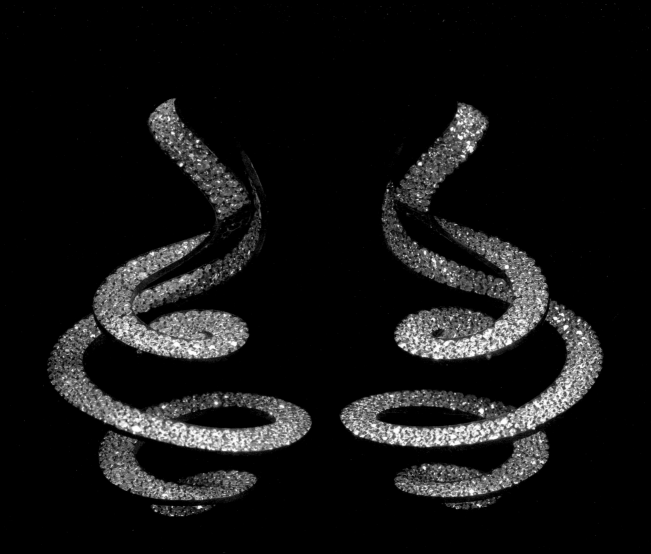

3. MULTICOLORED HANDKERCHIEF EARRINGS, 2011.
Sapphires, demantoid and other garnets, zircons,
tourmalines, emeralds, rubies, fire opals, spinels,
beryls, diamonds, platinum, silver, and gold

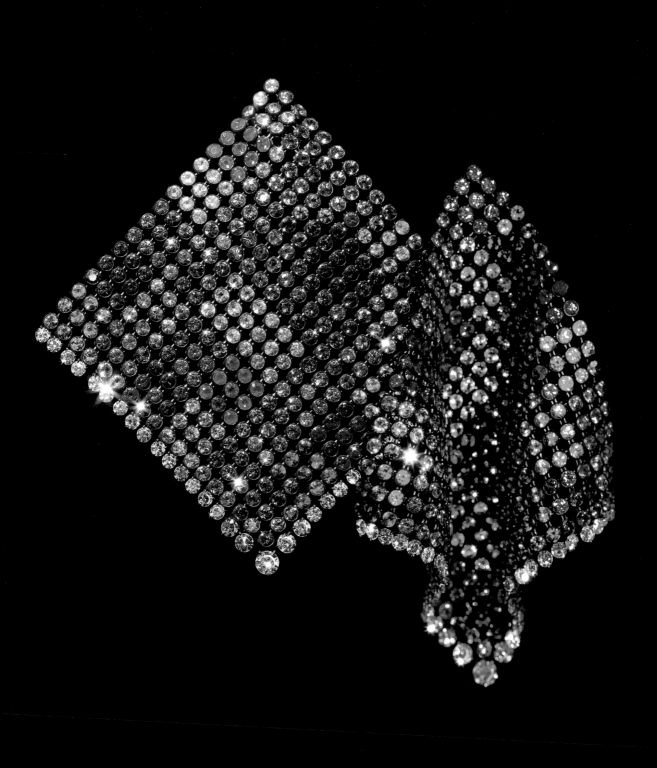

4. LIGHTNING NECKLACE, 2012. Aluminum, diamonds, silver, platinum, and gold

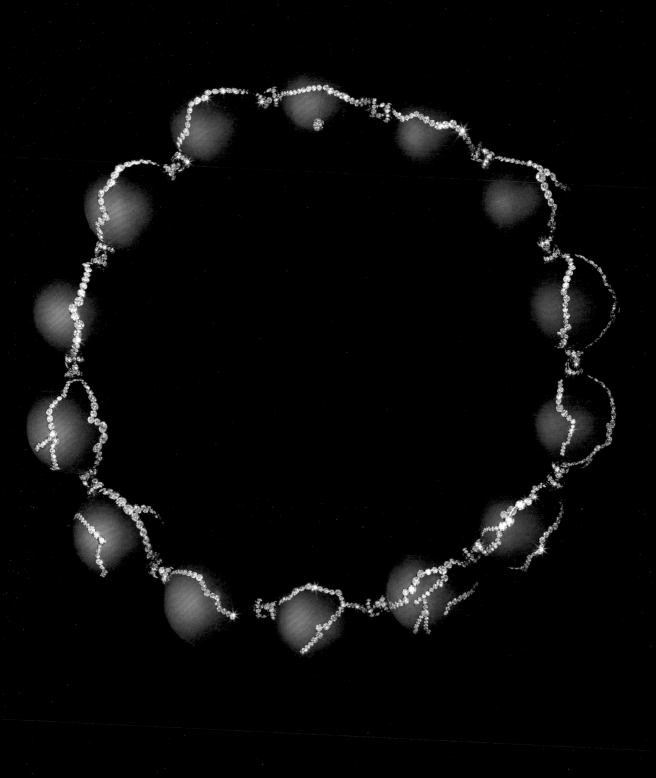

5. ROSE BROOCH, 2013. Rubies, pink sapphires, spinels, diamonds, silver, gold, and a cushion-shaped diamond

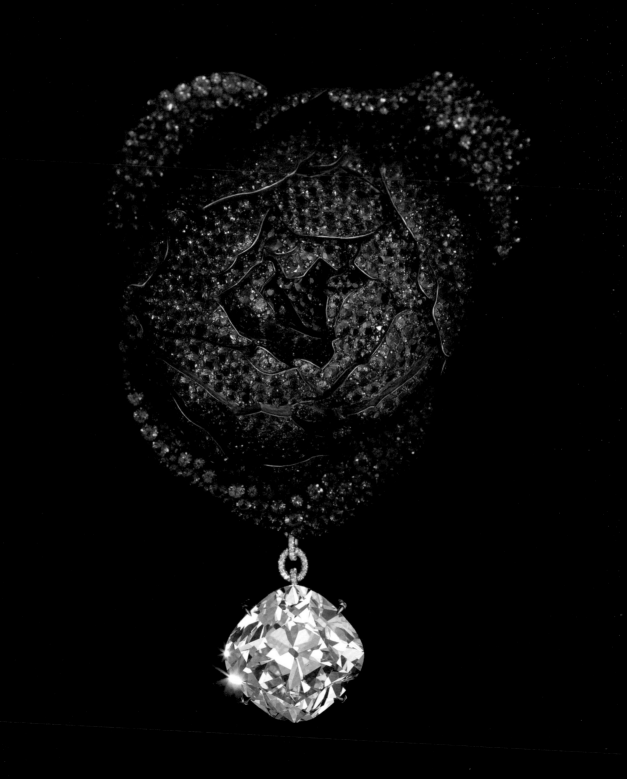

6. PENDANT EARRINGS, 2012. Oriental pearls, diamonds, and gold

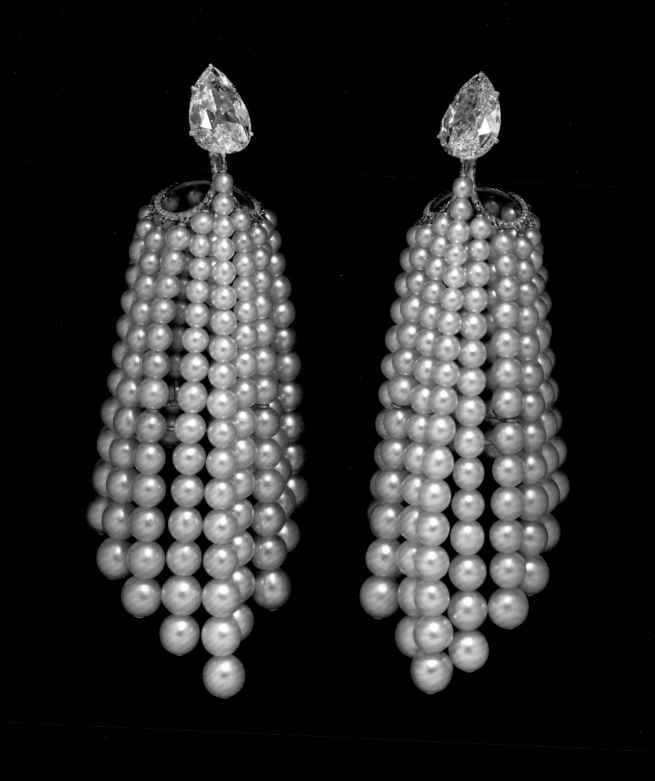

7. BROOCH, 2008. Diamonds, titanium, and gold

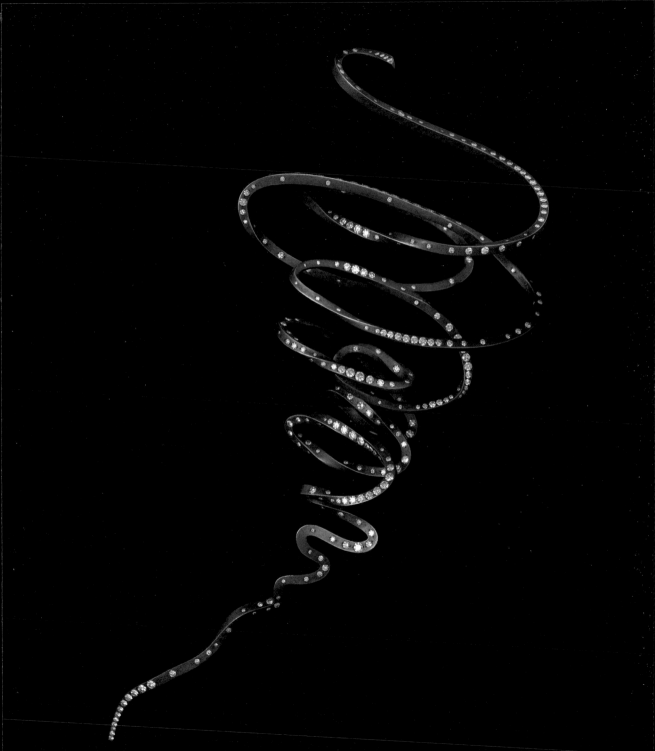

8. MUGHAL BROOCH, 2002 (*three views*). Emerald, rubies, diamonds, agate, rock crystal, silver, and gold

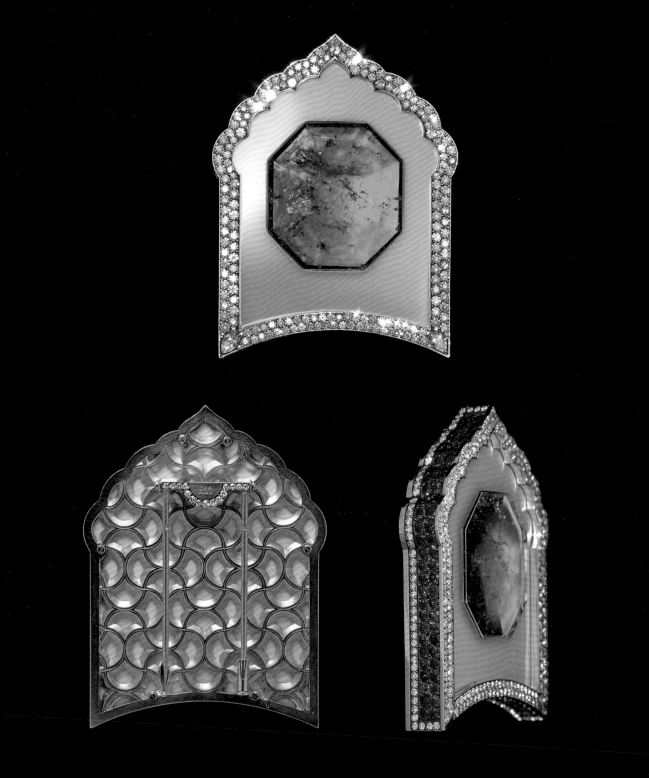

9. ZEBRA BROOCH, 1987. Agate, diamonds, a sapphire, silver, and gold

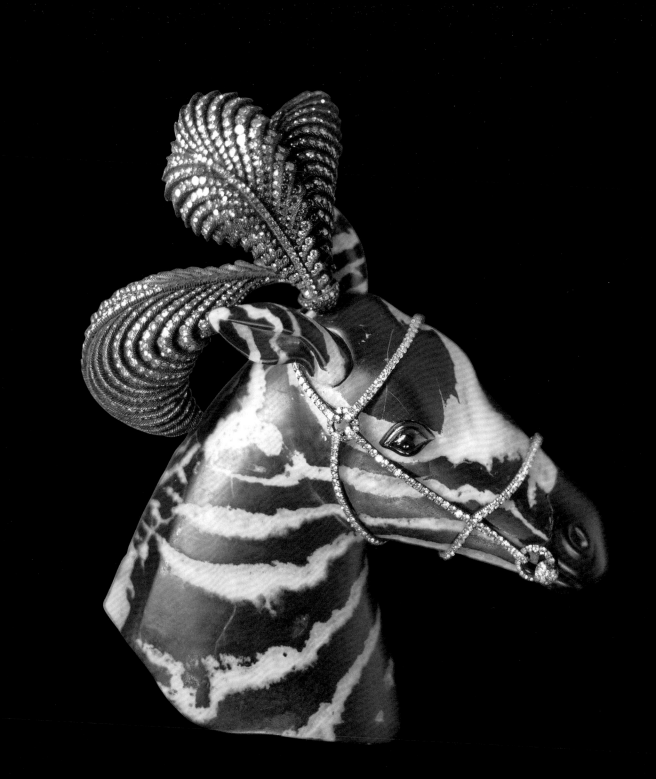

10. PENDANT BROOCH, 2003. Jade, garnets, sapphires, spinels, tourmalines, diamonds, silver, and gold

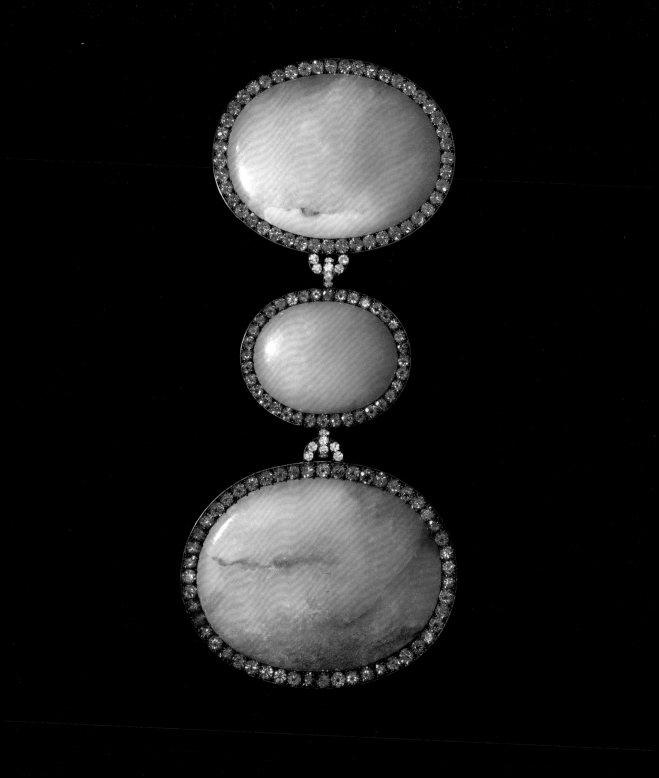

11. RASPBERRY BROOCH, 2011. Rubies, diamonds,
bronze, silver, gold, and platinum

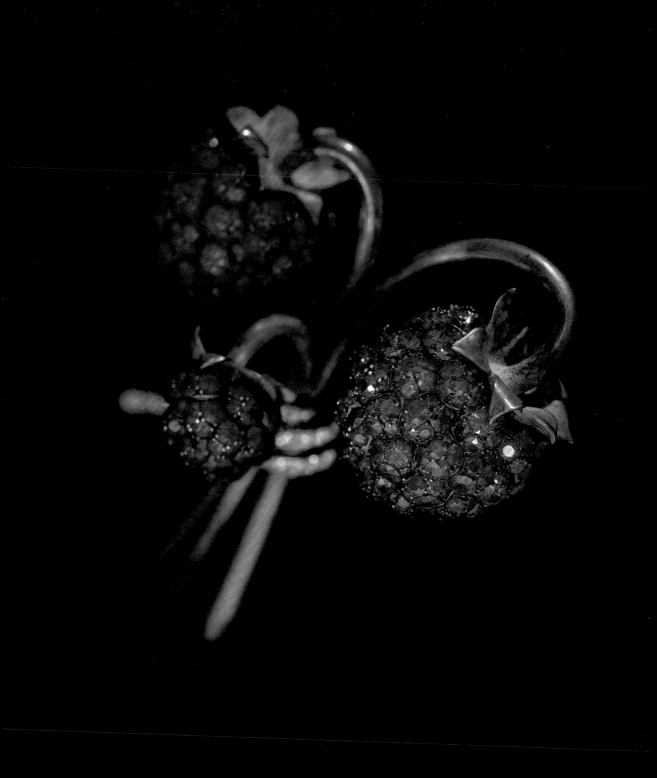

12. FLEXIBLE BRACELET, 2010. Diamonds and gold
13. FLEXIBLE BRACELET, 2010. Diamonds and gold

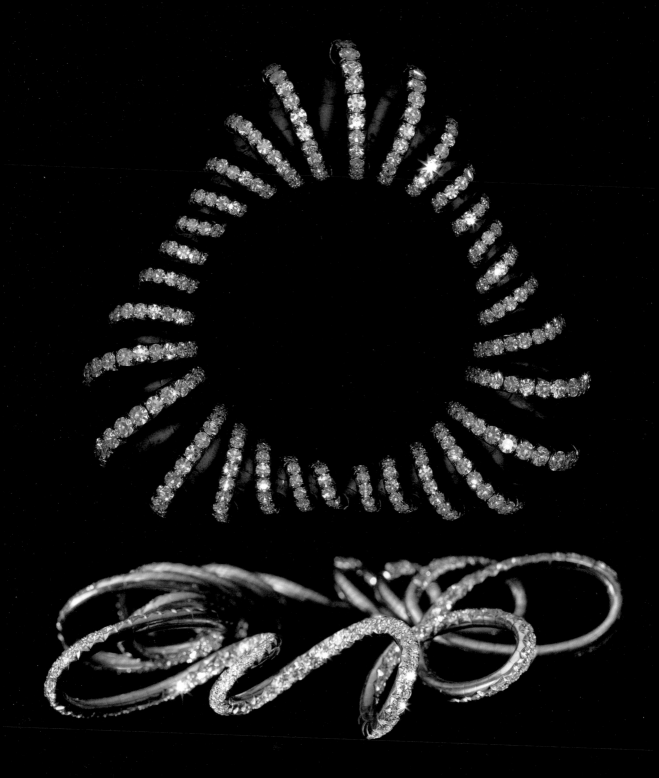

14. WILD ROSE BROOCHES, 1997. Sapphires, tourmalines, citrines, garnets, diamonds, silver, gold, and enamel

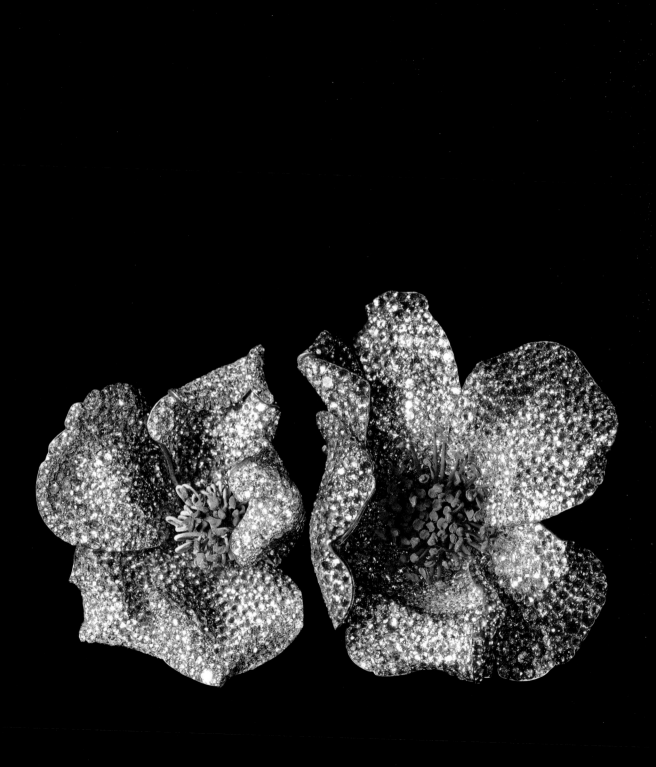

15. BANGLE BRACELET, 1988. Ebony, diamonds, and gold

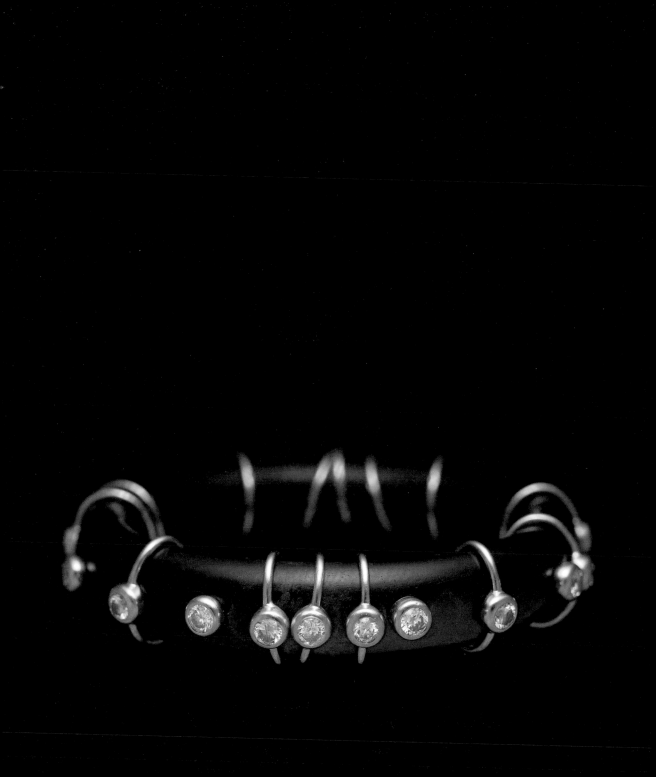

16. POPPY BROOCH, 1982. Diamond, tourmalines, and gold

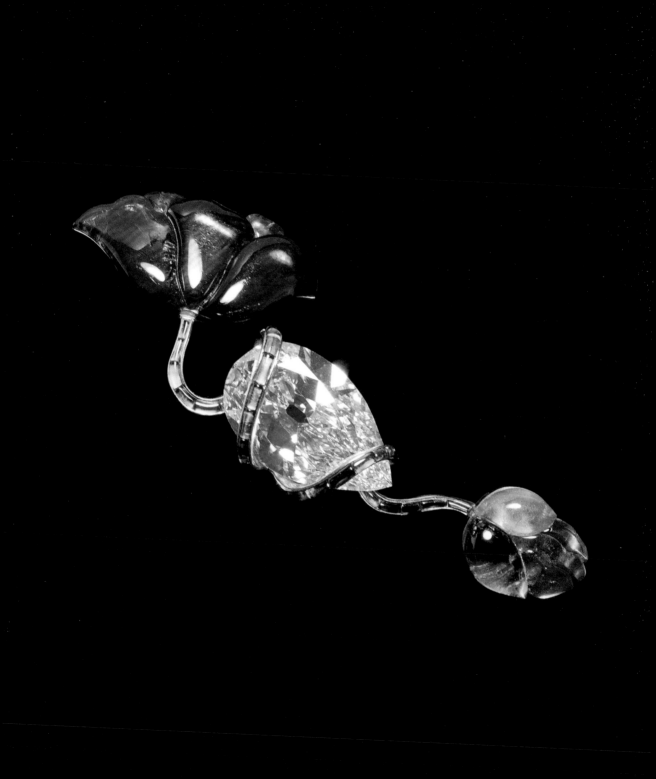

17. RIBBON EARRINGS, 2012. Sapphires, diamonds, silver, and gold

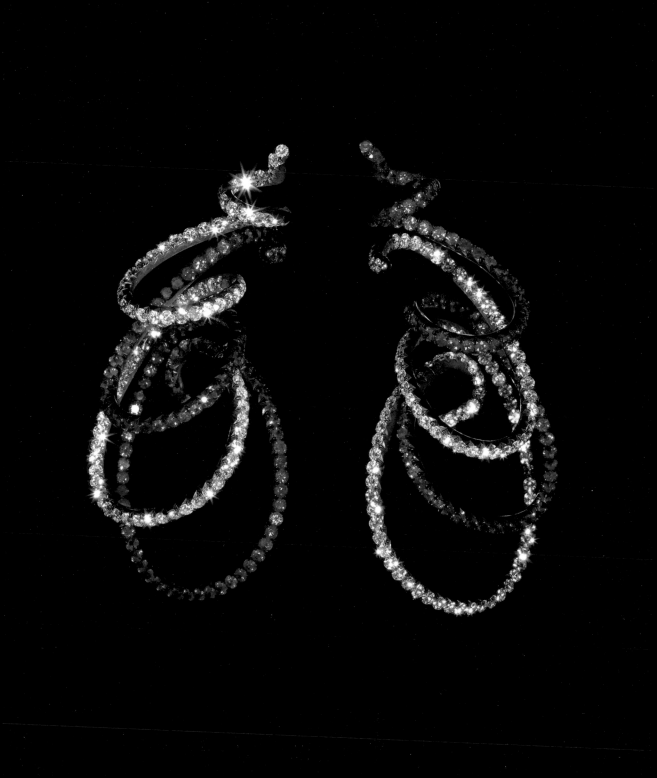

18. HOOP EARRINGS, 2008. Rubies, sapphires, diamonds, silver, and gold; 19. HOOP EARRINGS, 2010. Spinels, diamonds, silver, and gold

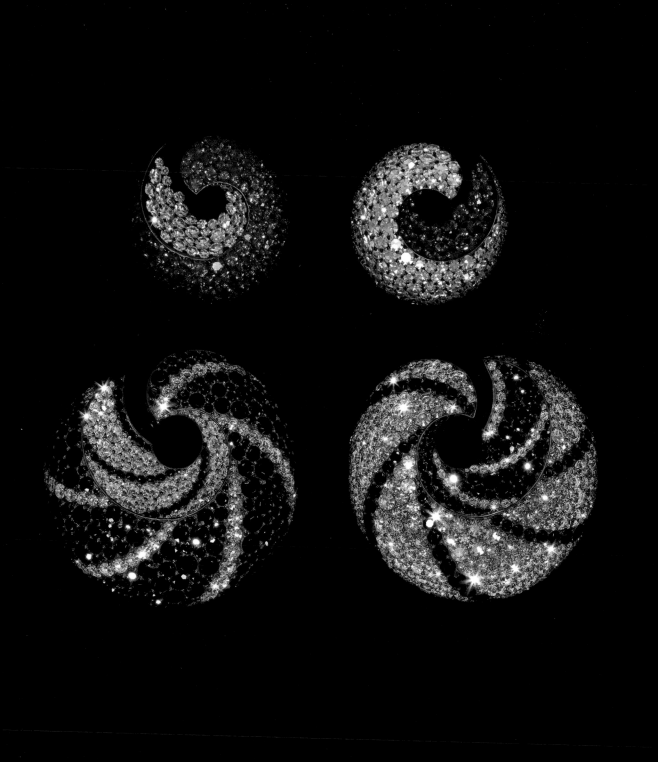

20. CAPILLARY FERN BROOCH, 1999. Diamonds, garnets, silver, and gold

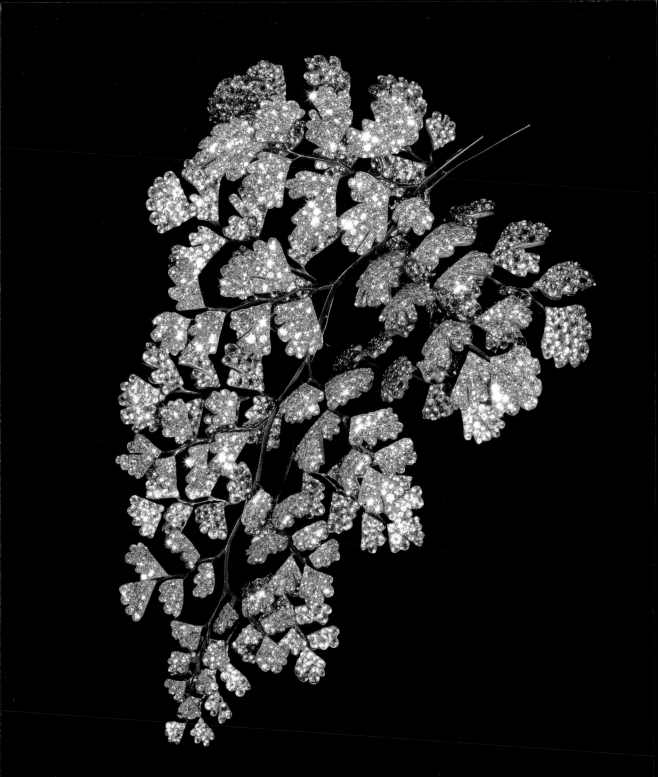

21. CUSHION CLOCK, 1997. Agate, diamonds, silver, and gold

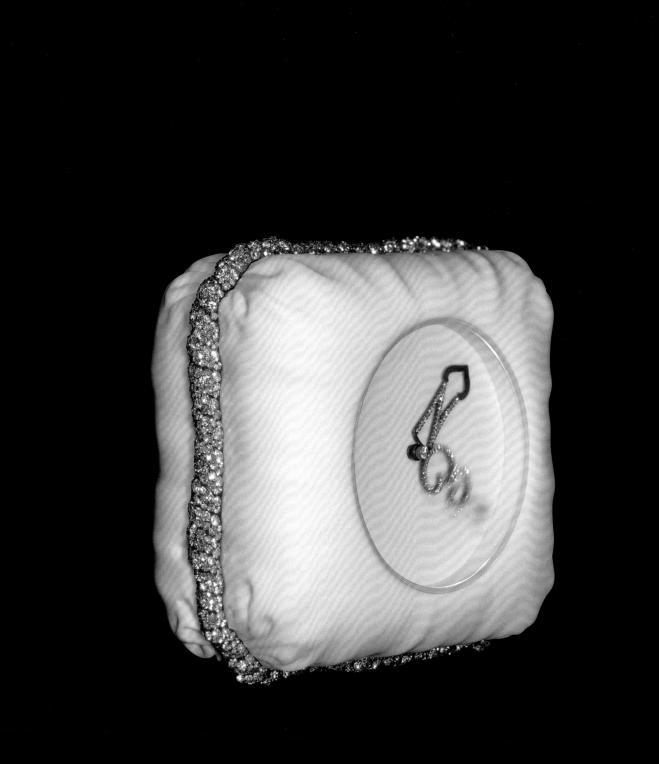

*Clockwise from top left:* 22. PANSY RING, 2009.
Green garnets, diamonds, silver, and gold; 23. PANSY
RING, 2009. Rubies, pink sapphires, diamonds, black
spinels, green garnets, silver, and gold; 24. PANSY
BRACELET, 2011. Garnets, sapphires, diamonds,
spinels, silver, gold, and platinum; 25. PANSY RING,
2010. Emeralds, demantoid garnets, spinels, diamonds,
silver, and gold; 26. PANSY BRACELET, 2012. Diamonds,
sapphires, garnets, tourmalines, topaz, chrysoberyls,
spinels, citrines, silver, platinum, and gold

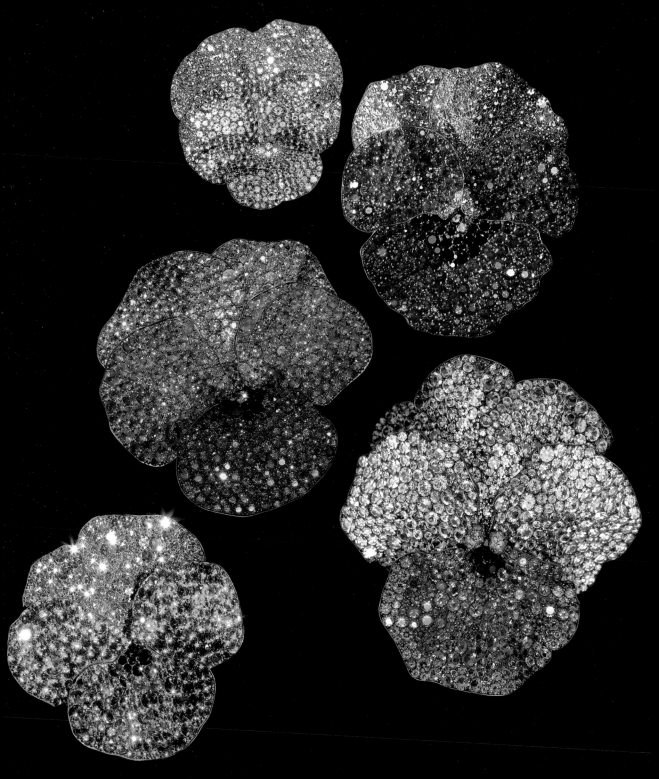

27. SHEEP'S HEAD BROOCH, 2006. Oriental pearls,
star sapphires, silver, and gold

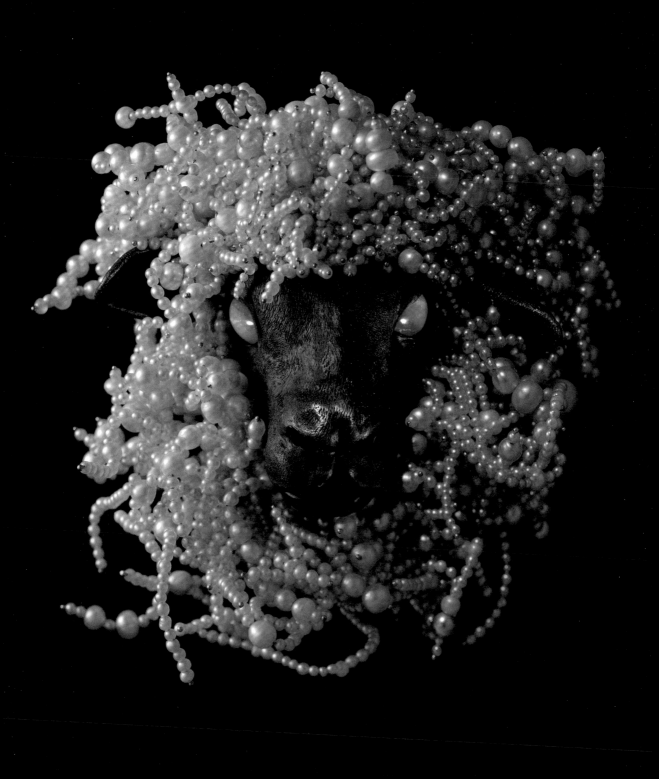

28. MUGHAL FLOWER BRACELET, 1987. Rubies, sapphires, amethysts, garnets, titanium, silver, and gold

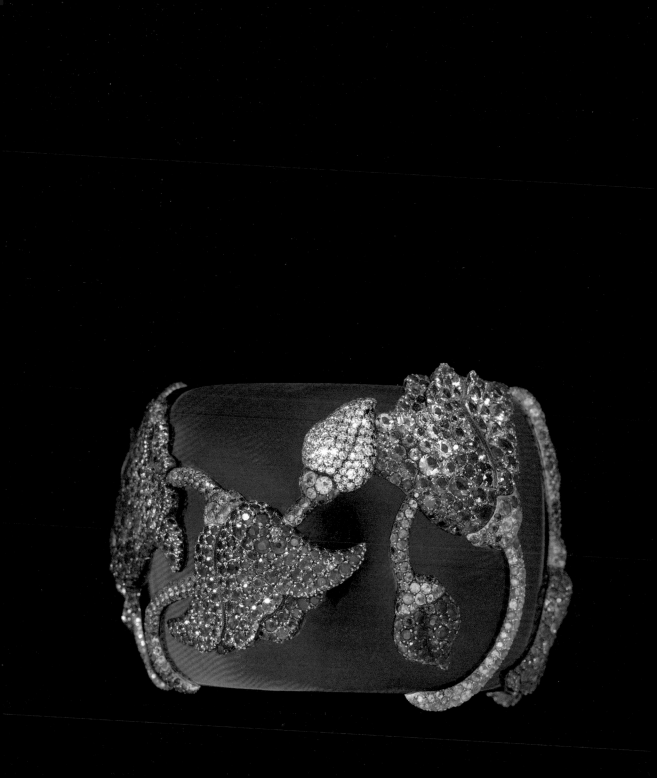

29. NECKLACE, 2005. Diamonds, grosgrain ribbon, silver, and gold

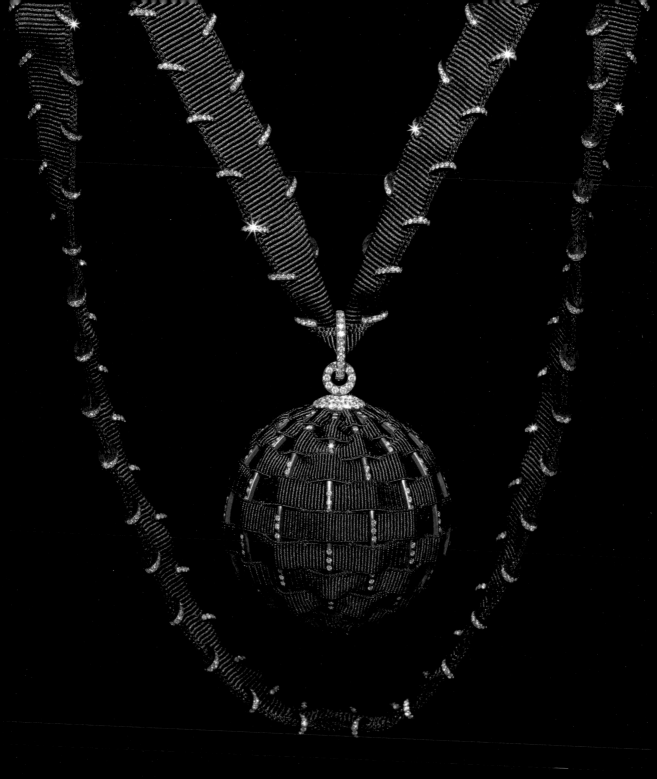

*Left and bottom:* 30. RING, 2012 (*two views*). Caramel diamond, rubies, diamonds, platinum, and gold; *top right:* 31. RING, 2012. Rubies, sapphires, diamonds, platinum, and gold

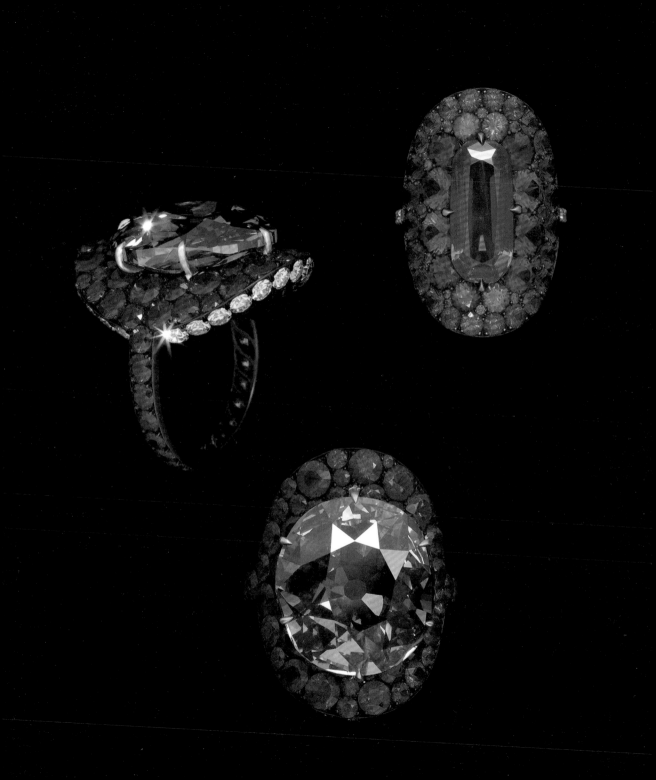

32. PENDANT EARRINGS, 2011. Beetle wings, emeralds, tsavorites and other garnets, diamonds, silver, and platinum

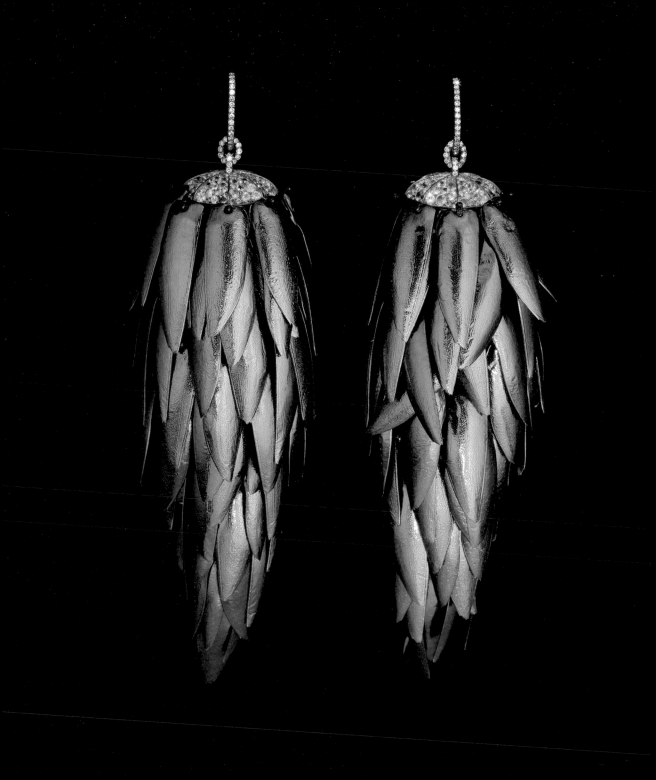

33. APRICOT BLOSSOM BRACELET, 2013. Morganite, diamonds, pink sapphires, bronze, silver, gold, and enamel

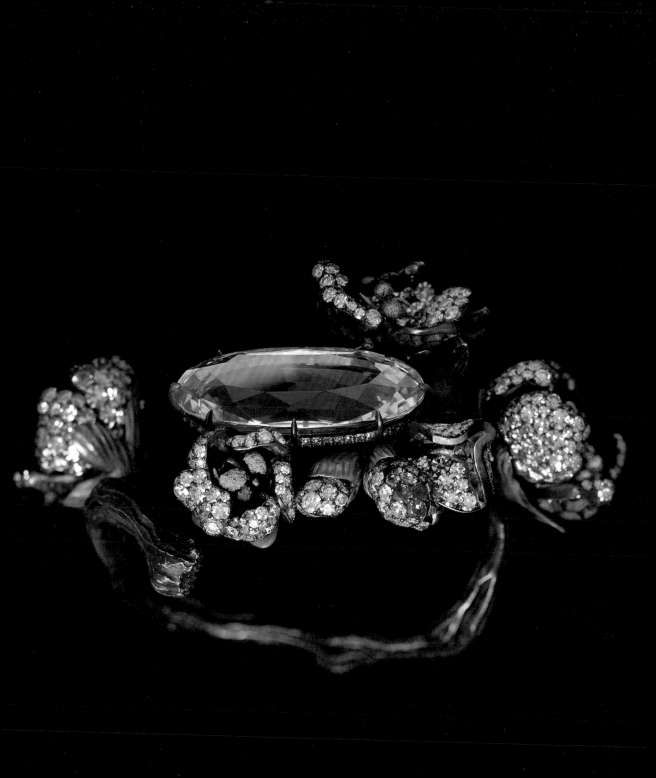

34. EARRINGS, 2011. Emeralds, oriental pearls, diamonds, and platinum

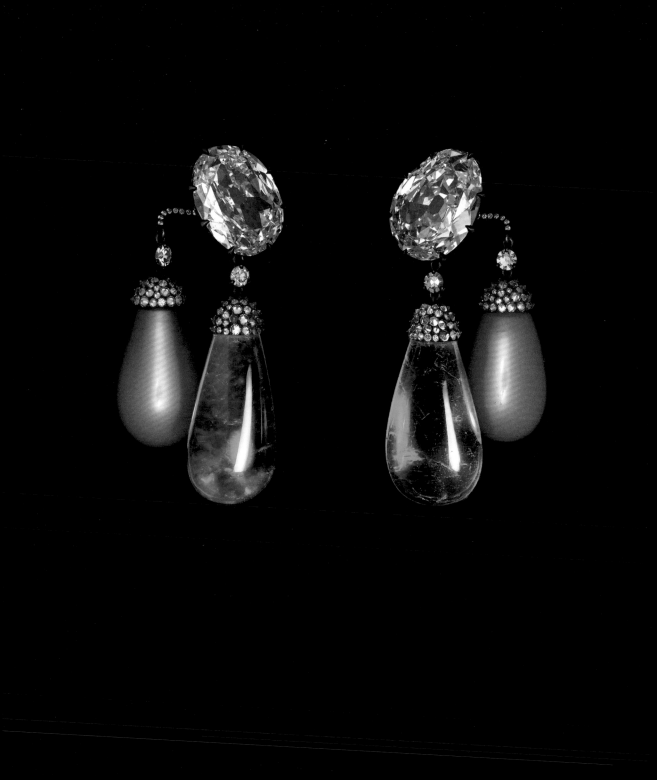

35. TULIP BROOCH, 2008. Rubies, diamonds, pink
sapphires, garnets, silver, gold, and enamel

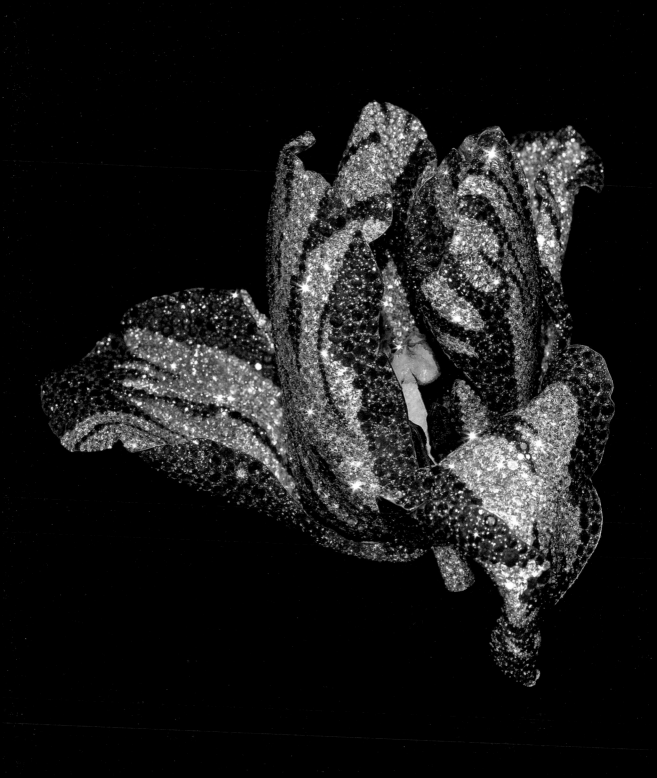

36. PENDANT EARRINGS, 1991. Oriental pearls, diamonds, platinum, and gold

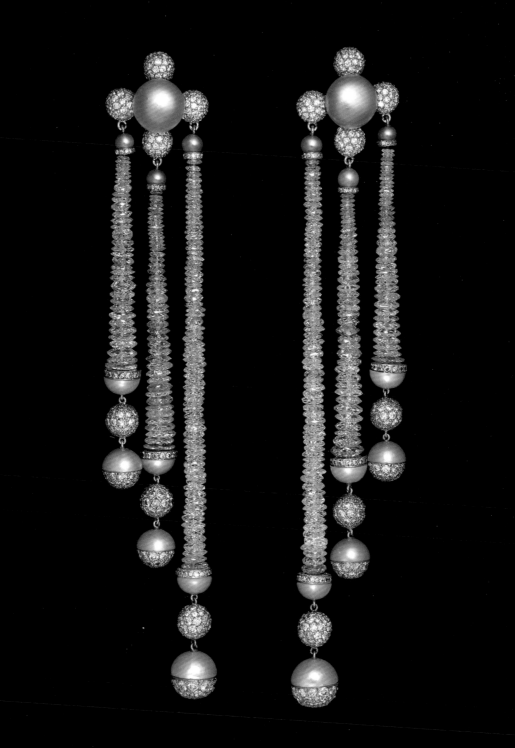

37. CAMELLIA BROOCH, 2005. Aluminum, diamonds, silver, gold, and enamel

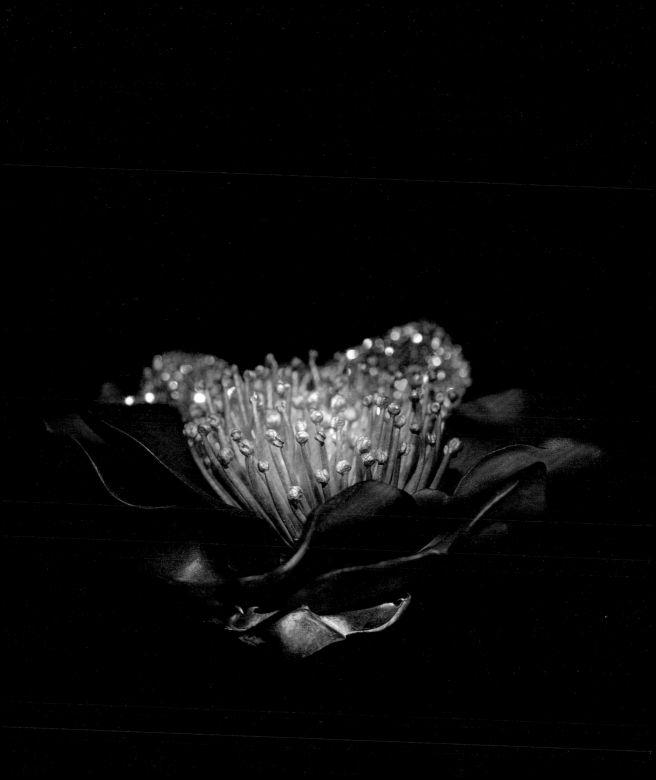

38. EARRINGS, 2007. Diamonds and titanium

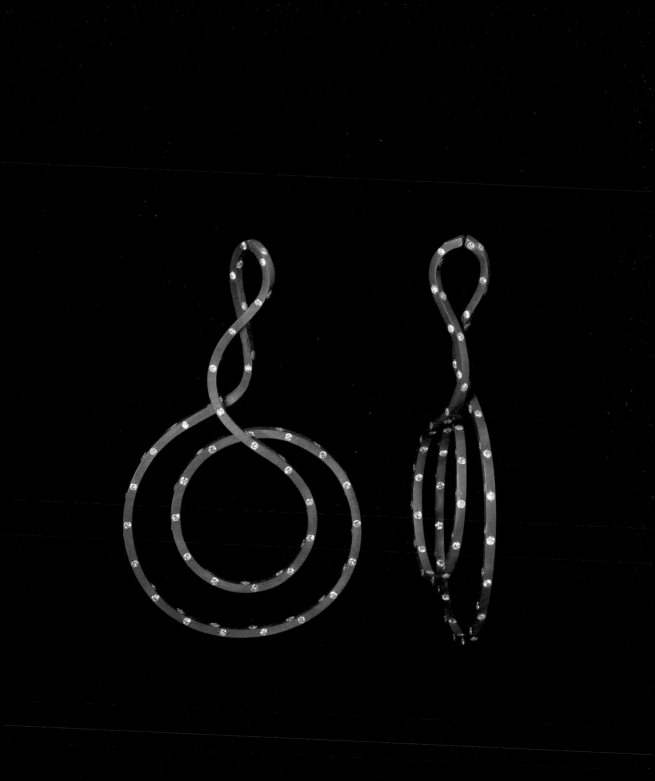

39. SEESAW EARRINGS, 2010. Kunzite, pink sapphires, diamonds, platinum, silver, and gold

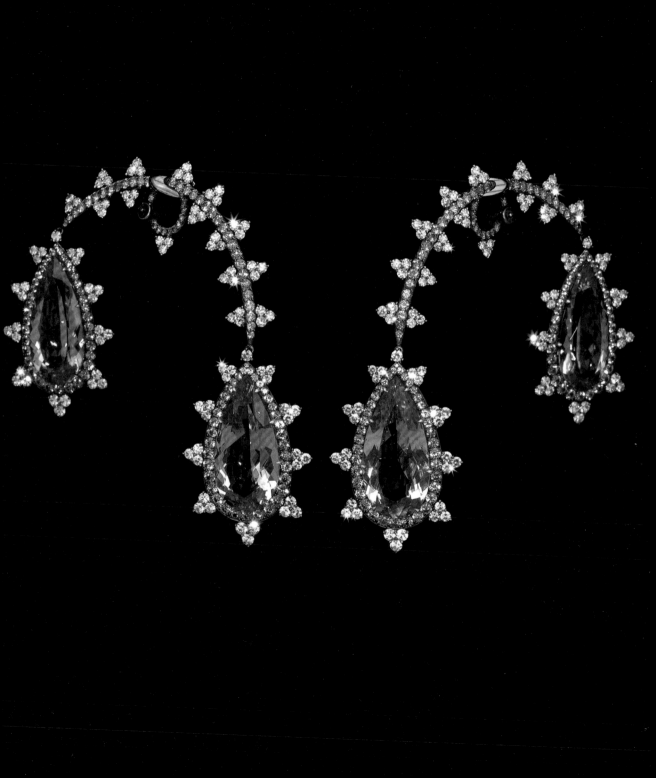

40. SEASHELL BROOCH, 2009 (*two views*).

Spinels, diamonds, silver, and gold

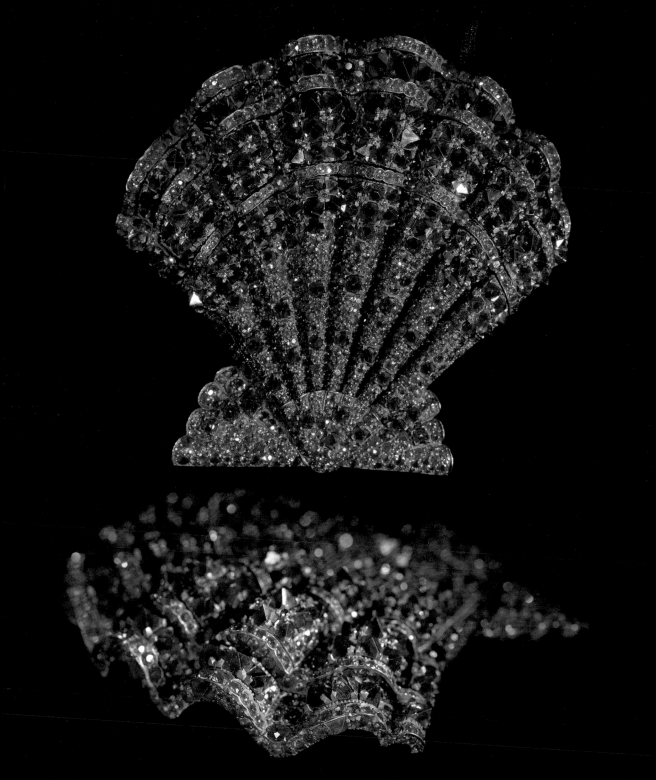

41. EARRINGS, 2010. Diamonds, silver, and gold

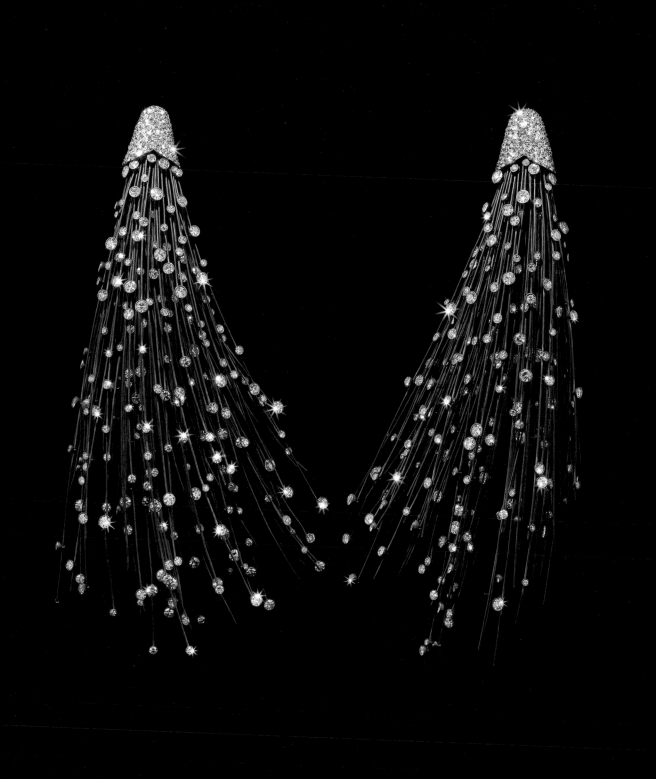

42. FOLDED BUTTERFLY BROOCH, 2011. Topaz, diamonds, sapphires, silver, and gold

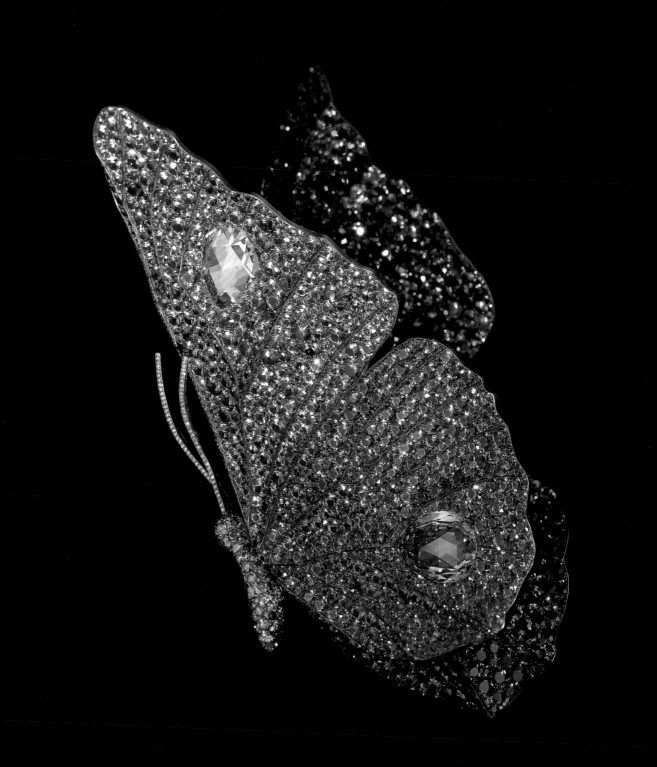

43. GERANIUM BROOCH, 2007. Diamonds, aluminum, silver, and gold

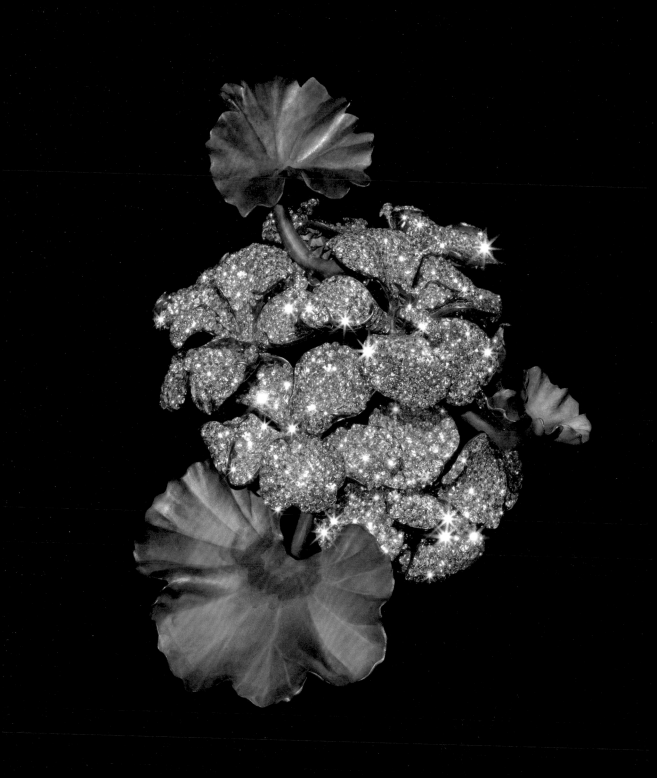

44. STRAWBERRY PENDANT EARRINGS, 2011.

Sapphires, diamonds, bronze, silver, platinum, and gold

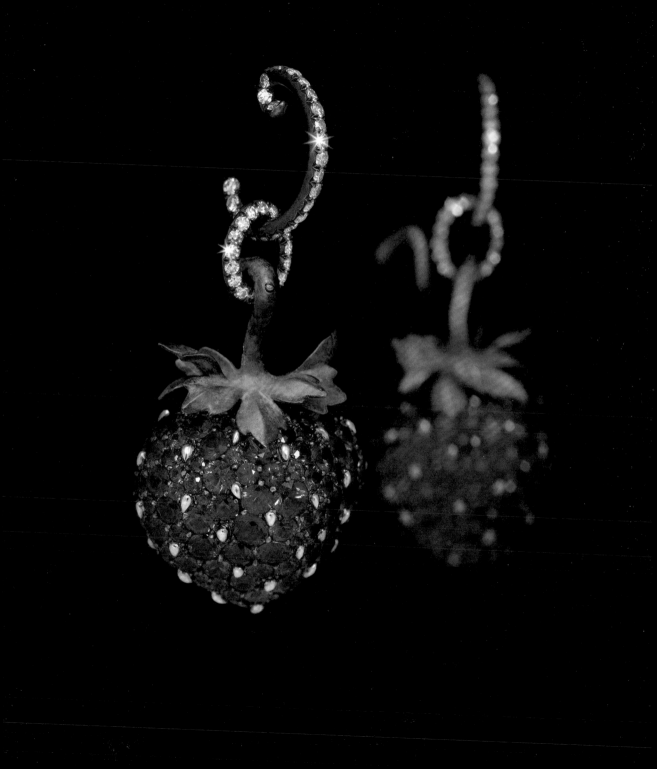

45. FOUNTAIN PENDANT EARRINGS, 2011.

Aquamarines, diamonds, silver, and gold

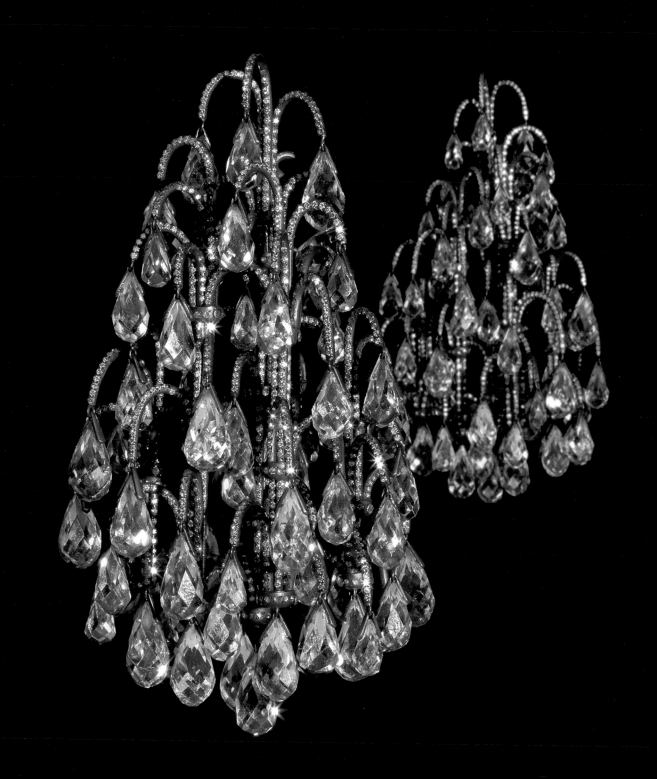

46. COLORED BALLS NECKLACE, 1999. Rubies, sapphires, emeralds, amethysts, spinels, garnets, opals, tourmalines, aquamarines, citrines, diamonds, silver, and gold

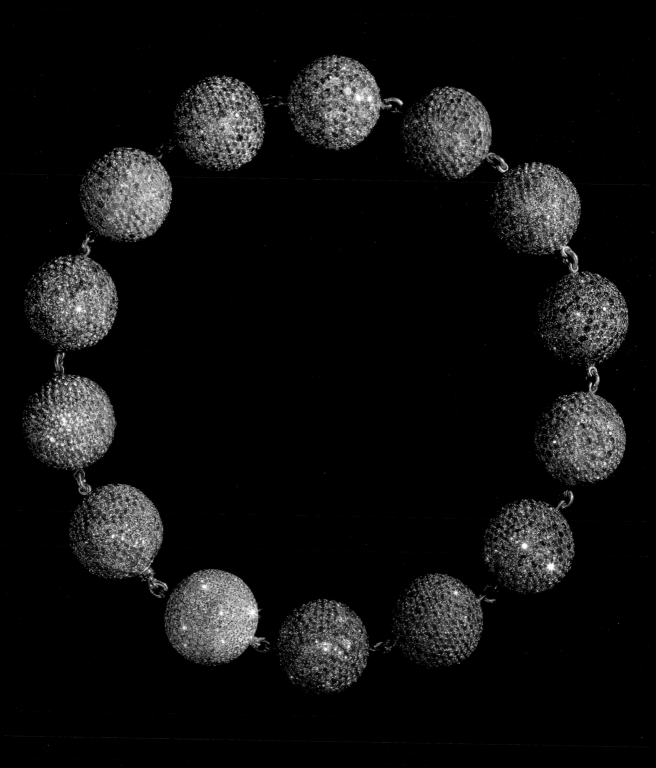

47. RING, 2004. Diamonds and platinum

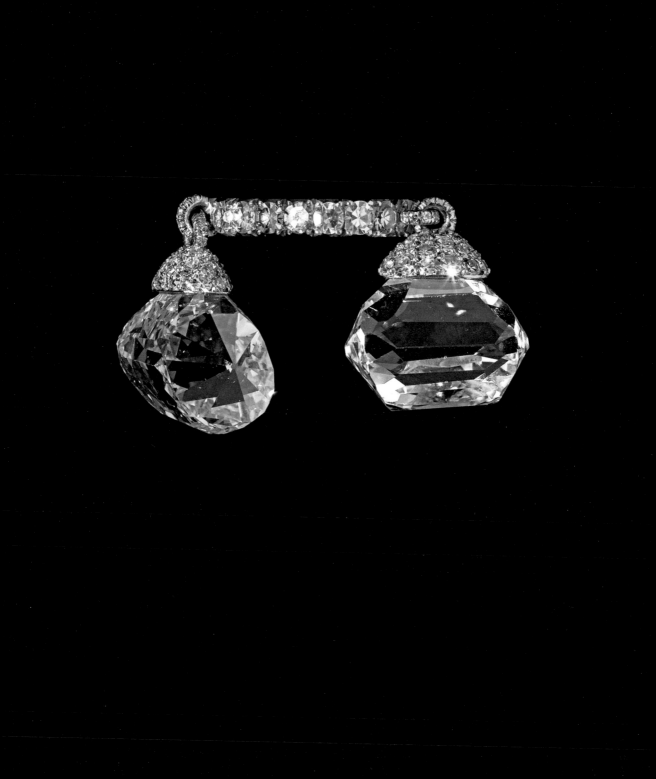

48. BUTTERFLY BROOCH, 2011. Moonstones, sapphires, spinels, silver, and gold

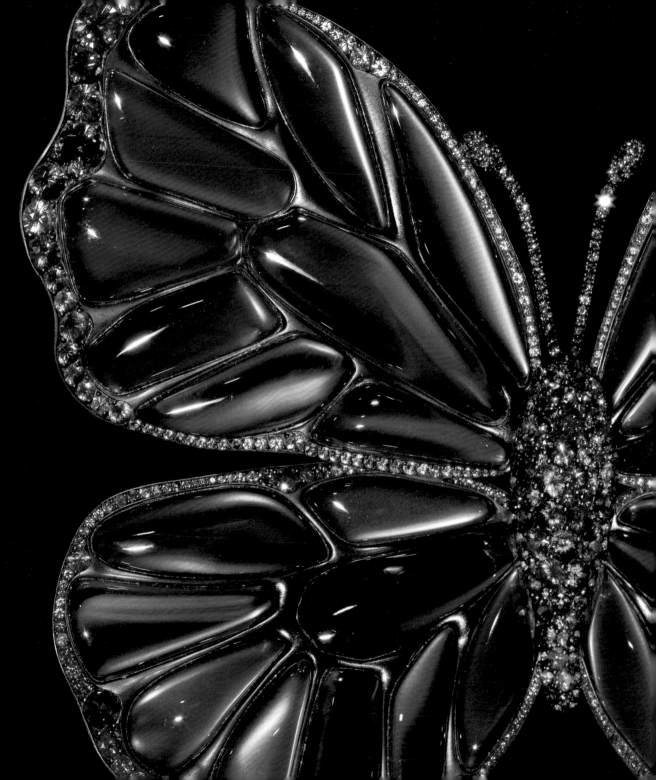

49. HELLEBORE BROOCH IN ITS SNOWBALL BOX, 2004. Violet sapphires, demantoid garnets, diamonds, rock crystal, silver, gold, and enamel

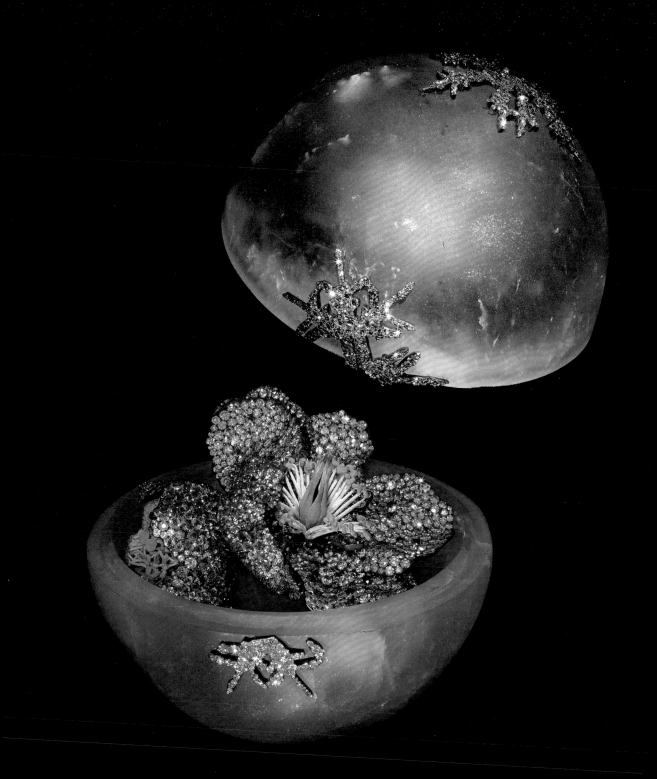

50. GARDENIA RING, 2004. Diamonds, silver, and gold

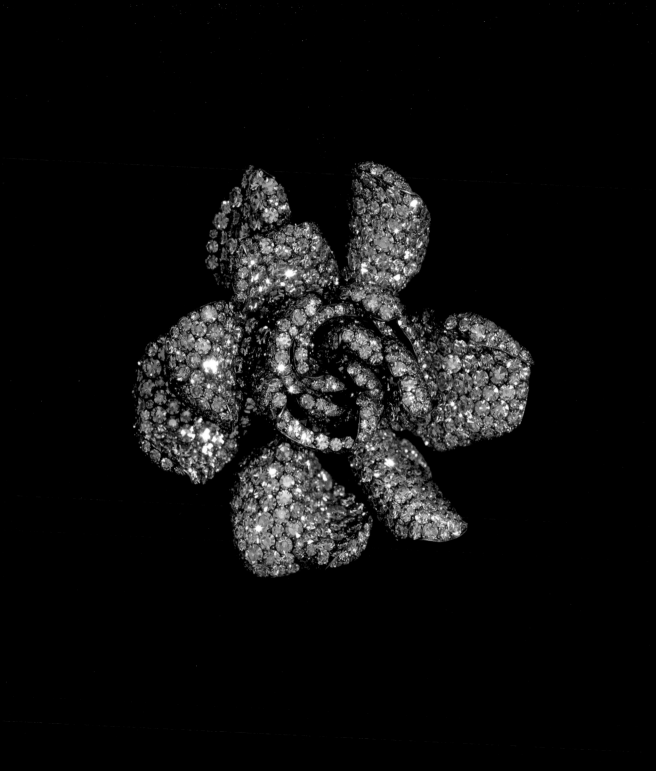

51. WEEPING WILLOW PENDANT EARRINGS, 2011.
Chrysoberyls, tourmalines, diamonds, platinum,
silver, and gold

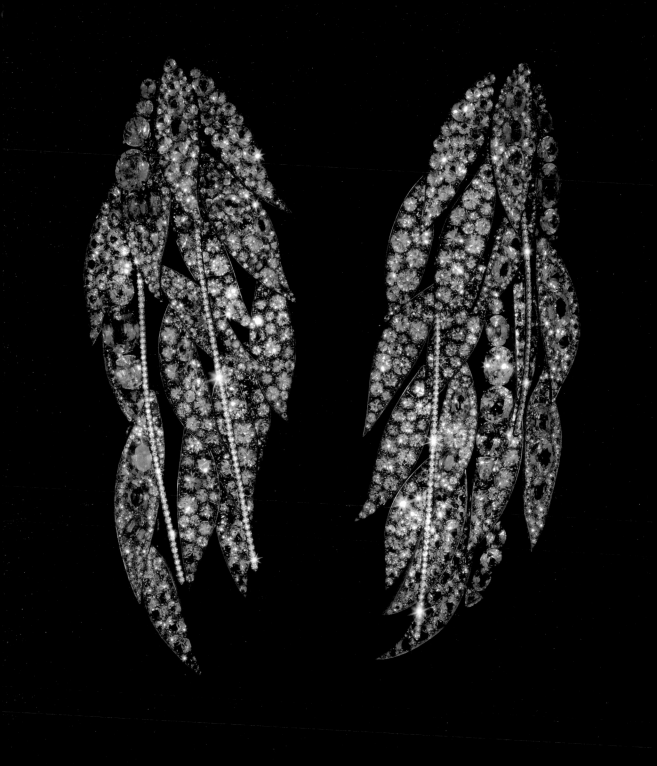

52. MUGHAL RING, 2008. Rubies, oriental pearls, diamonds, silver, and gold

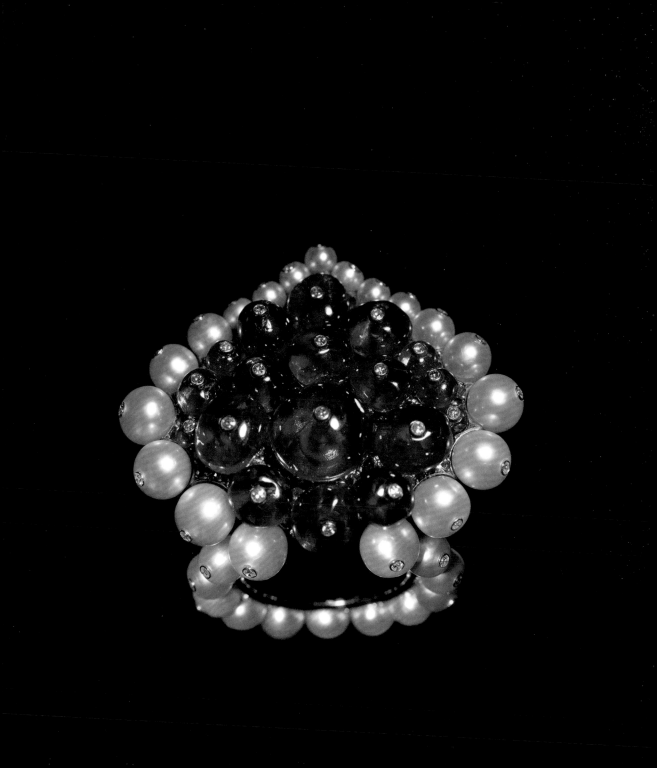

53. RADISH AND CARROT EARRINGS, 2013. Sapphires,
opals, demantoid garnets, diamonds, silver, and gold

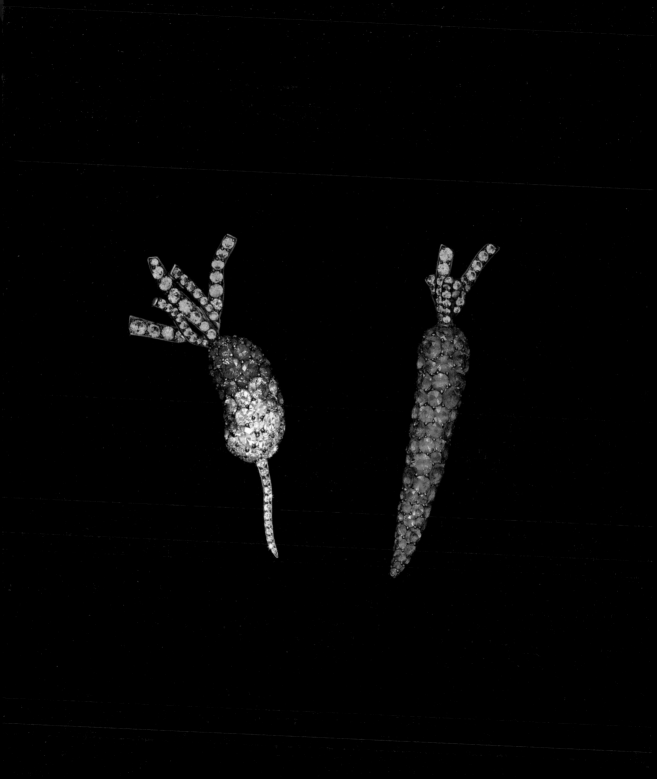

54. WAVE BROOCH, 2006. Beryls, chrysoberyls,
sapphires, tourmalines, diamonds, silver, and gold

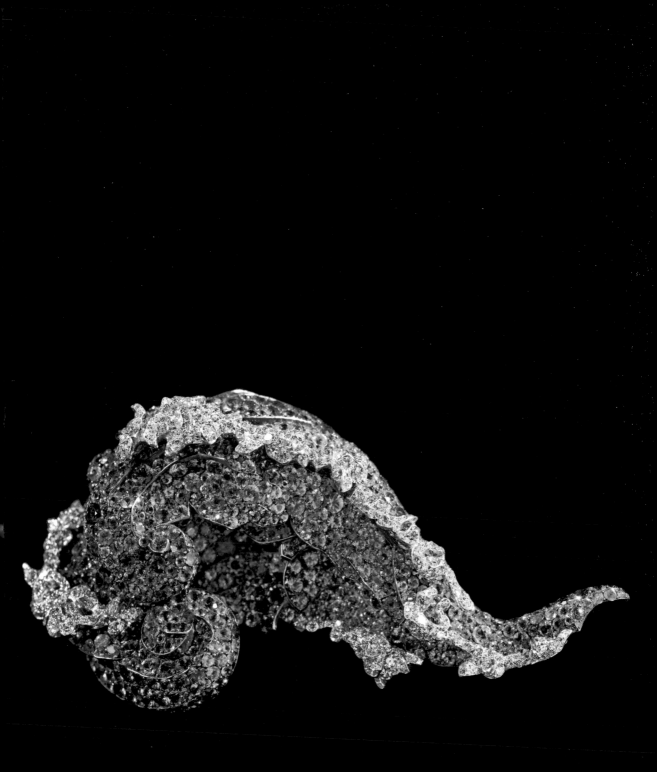

55. ASPARAGUS BROOCHES, 2008. Chrysoberyls,
demantoid and other garnets, peridots, green and
violet sapphires, spinels, tourmalines, silver, and gold

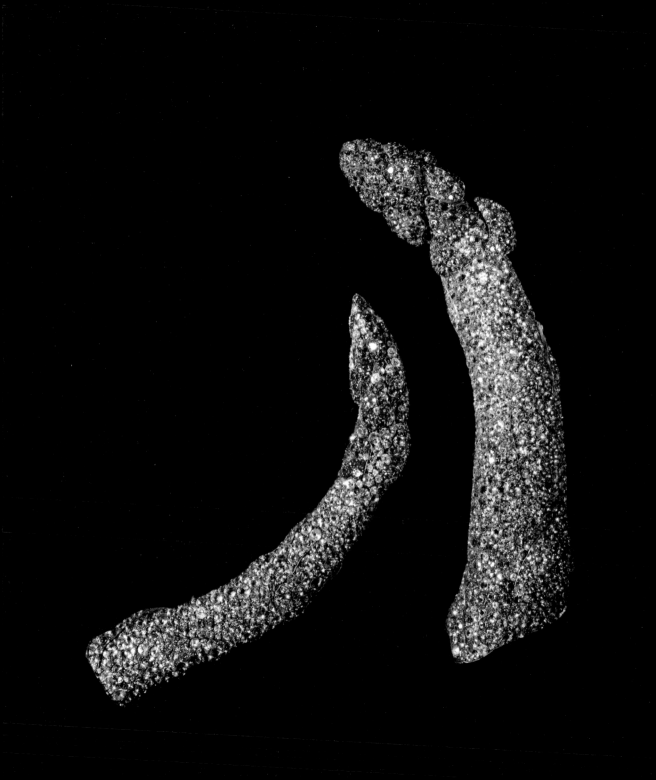

56. LILY PETAL BROOCH, 2006. Diamonds, garnets, silver, gold, and enamel

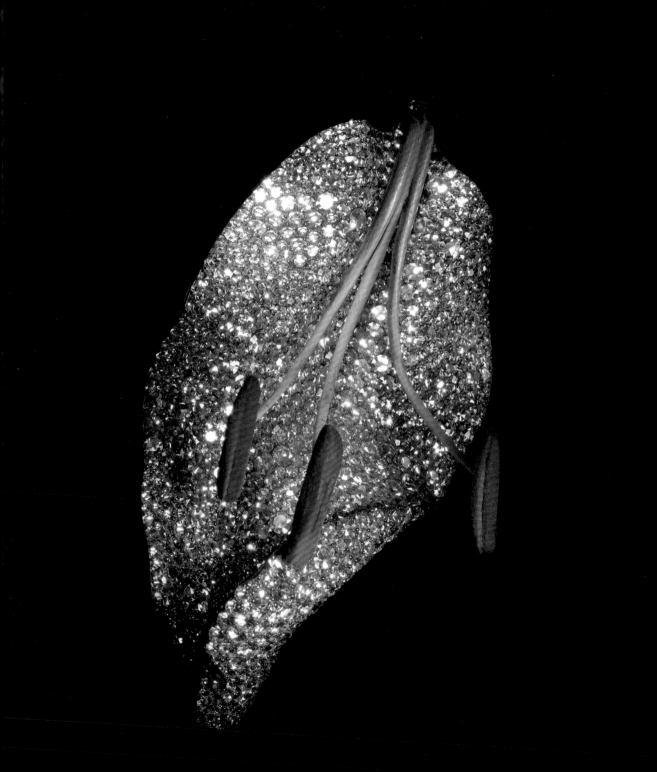

57. CAMEO AND ROSE PETAL BROOCH, 2011. Antique cameo, rubies, brown diamonds, silver, and gold

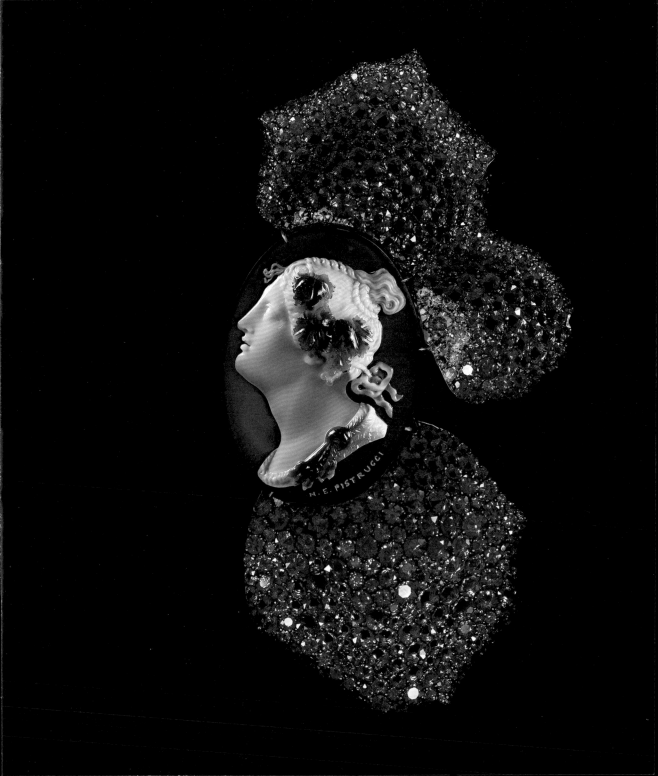

58. LILAC BROOCHES, 2001. Diamonds, lilac sapphires, garnets, aluminum, silver, and gold

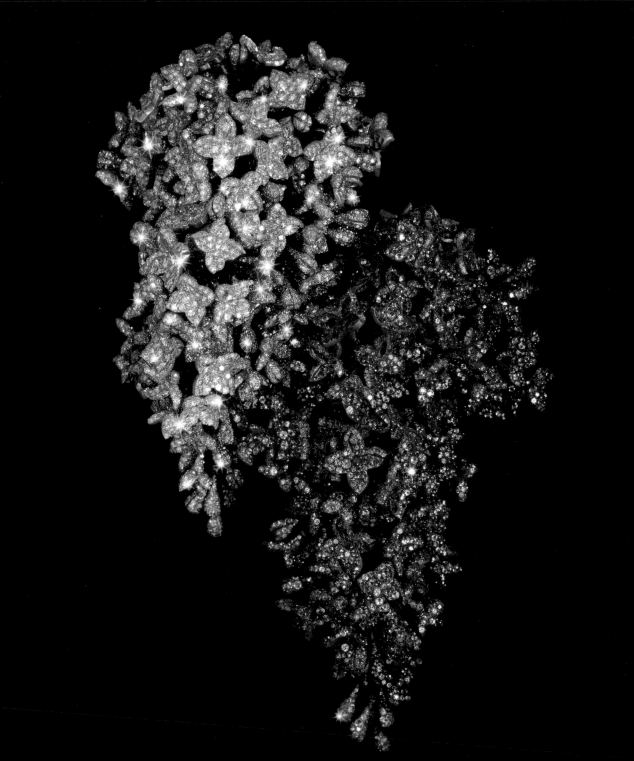

59. BRACELET, 2010. Diamonds, silver, and platinum

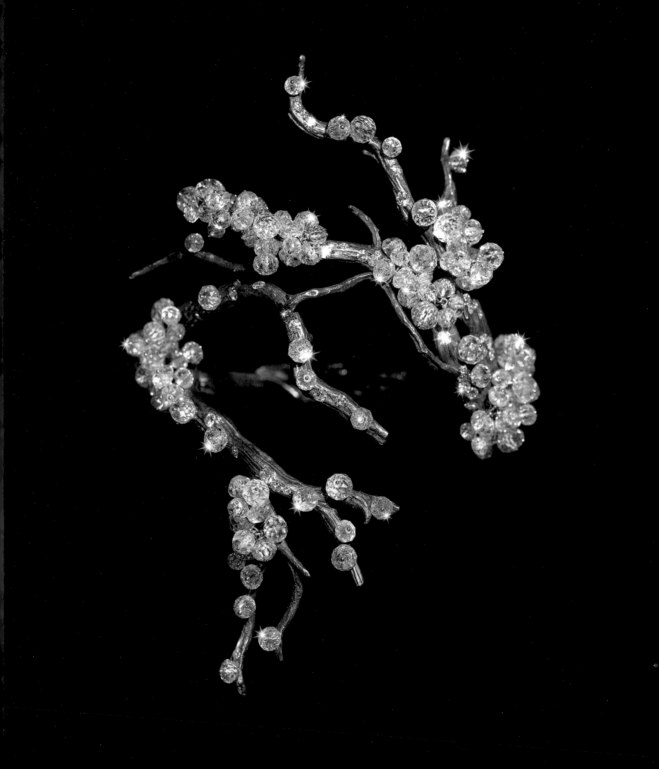

60. CORAL BRACELETS, 2011. Coral and gold

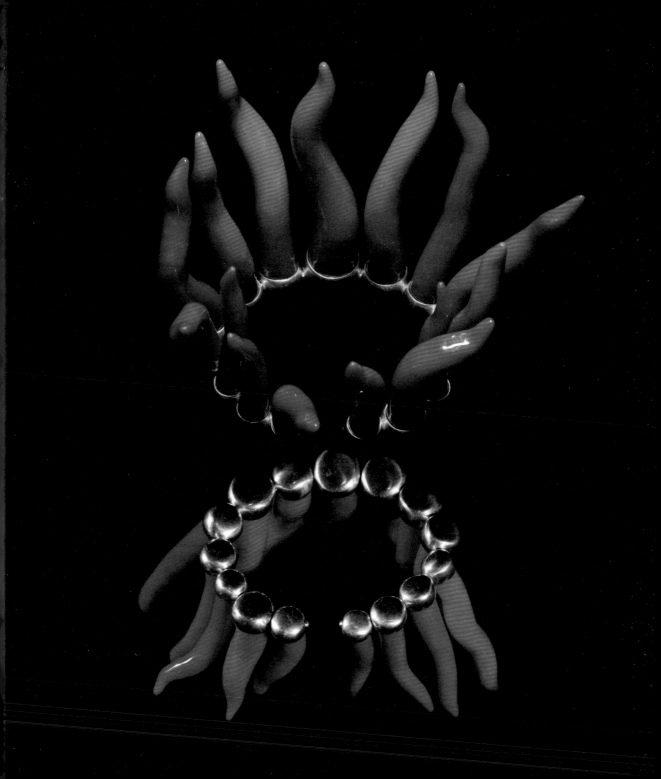

*Clockwise from top left:* 61. GERANIUM LEAF EARRING, 2009. Gilded aluminum and gold; 62. EARRING, 2013. Glass and titanium; 63. GARDENIA EARRING, 2012. Resin and gold; 64. GERANIUM LEAF EARRING, 2009. Aluminum and gold

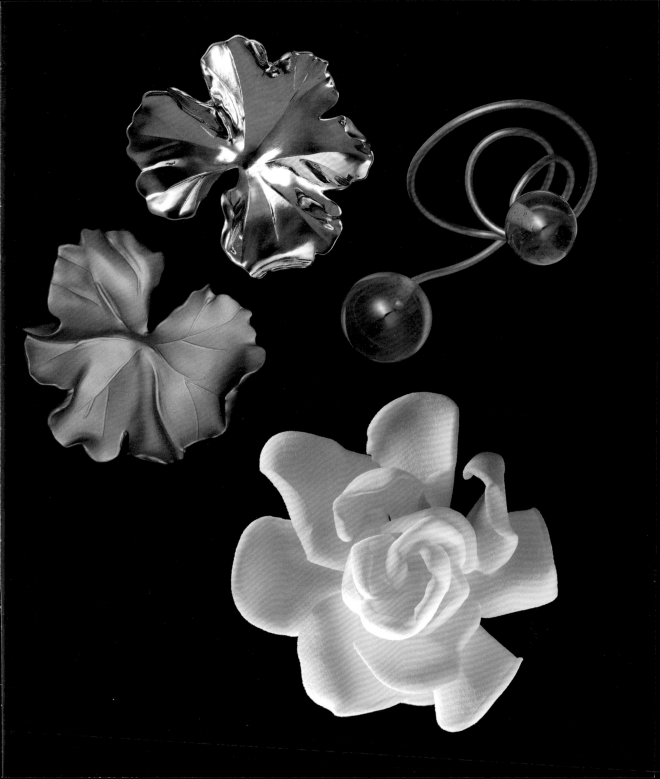

65. BUTTERFLY BROOCH, 1994. Sapphires, fire opals, rubies, amethysts, garnets, diamonds, silver, and gold

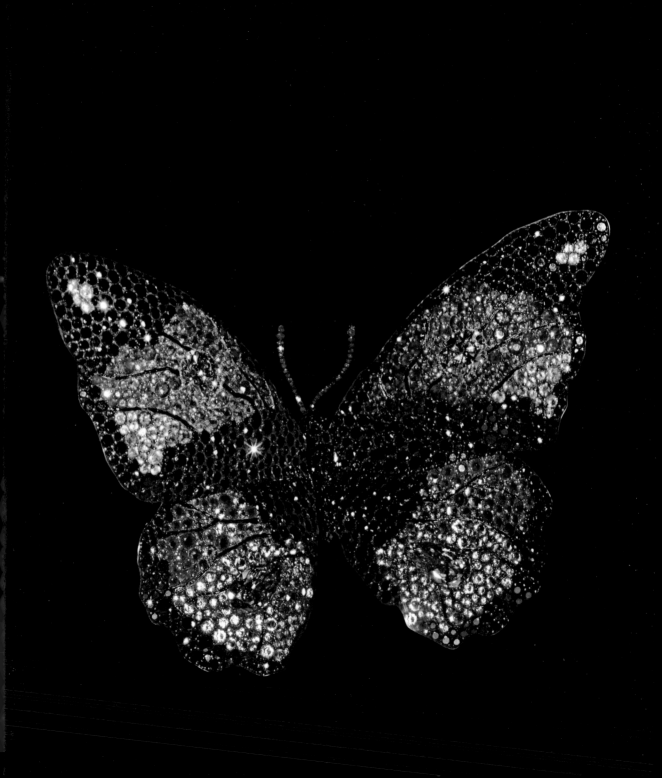

## ABOUT THE AUTHOR

Adrian Sassoon is a London-based specialist in French eighteenth-century Sèvres porcelain and author of *Vincennes and Sèvres Porcelain: Catalogue of the Collections, The J. Paul Getty Museum*. He deals privately in Sèvres porcelain, as well as publicly in contemporary ceramics, glass, and silver made by studio artists. He is a trustee of The Wallace Collection and of The Silver Trust (for 10 Downing Street), both in London, as well as of the Hermitage Foundation UK, Saint Petersburg.

This catalogue is published in conjunction with "Jewels by JAR," on view at The Metropolitan Museum of Art, New York, from November 20, 2013, through March 9, 2014.

The exhibition is made possible by Phaidon Press Limited, Nancy and Howard Marks, The Ronald and Jo Carole Lauder Foundation, and Mr. and Mrs. George S. Livanos.

**Published by The Metropolitan Museum of Art**, New York
Mark Polizzotti, Publisher and Editor in Chief
Gwen Roginsky, Associate Publisher and General Manager
  of Publications
Peter Antony, Chief Production Manager
Michael Sittenfeld, Managing Editor
Robert Weisberg, Senior Project Manager

Designed by Glue + Paper Workshop, LLC, Chicago, Illinois
Production by Peter Antony and Sally Van Devanter

Photographs by Jozsef Tari, except for the photograph on page 24 and plates 9, 14, 16, 20, 21, and 65, which are by Katharina Faerber. Courtesy of JAR, Paris

Typeset in HTF Didot and Gotham
Printed on 170 gsm Perigord
Separations by Professional Graphics, Inc., Rockford, Illinois
Printed and bound at Graphicom S.r.l., Verona, Italy

Cover illustration: Butterfly Brooch, 1994 (pl. 65)
Page 3: Camellia Brooch, 2005 (pl. 37)
Page 5: Colored Balls Necklace, 1999 (pl. 46)
Pages 11, 12: Tulip Brooch, 2008 (pl. 35)

Third printing, 2013

The Metropolitan Museum of Art
1000 Fifth Avenue
New York, New York 10028
metmuseum.org

Distributed by
Yale University Press, New Haven and London
yalebooks.com/art
yalebooks.co.uk

Cataloging-in-Publication Data is available from the Library of Congress.
ISBN 978-1-58839-531-3 (The Metropolitan Museum of Art)
ISBN 978-0-300-19868-3 (Yale University Press)